PAPER LITHOGRAPHY

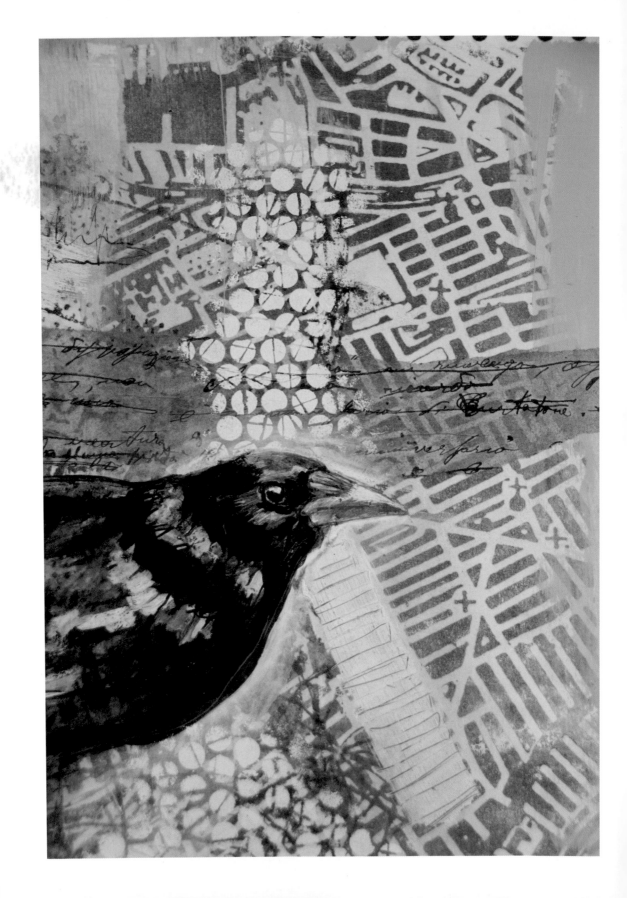

Sue Brown

PAPER LITHOGRAPHY

THE CROWOOD PRESS

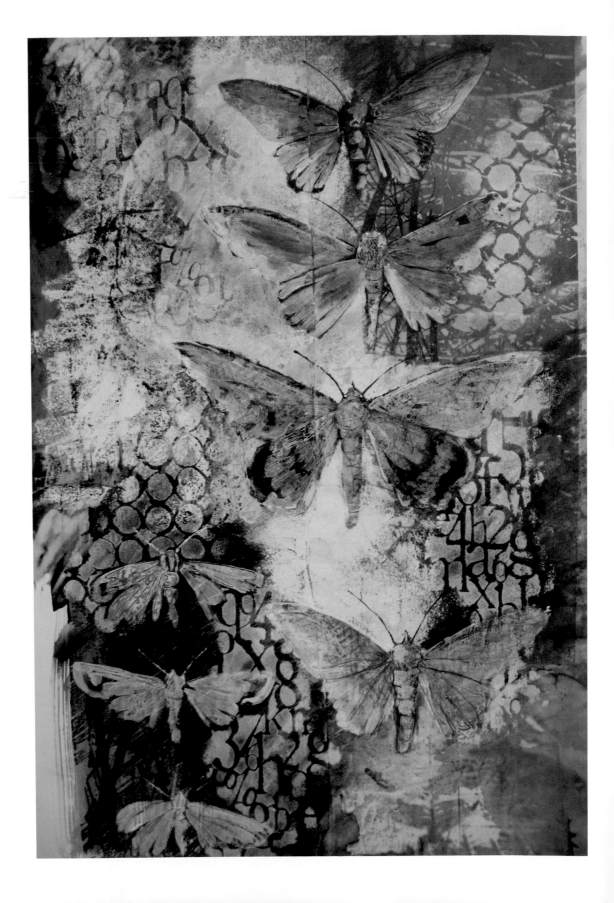

CONTENTS

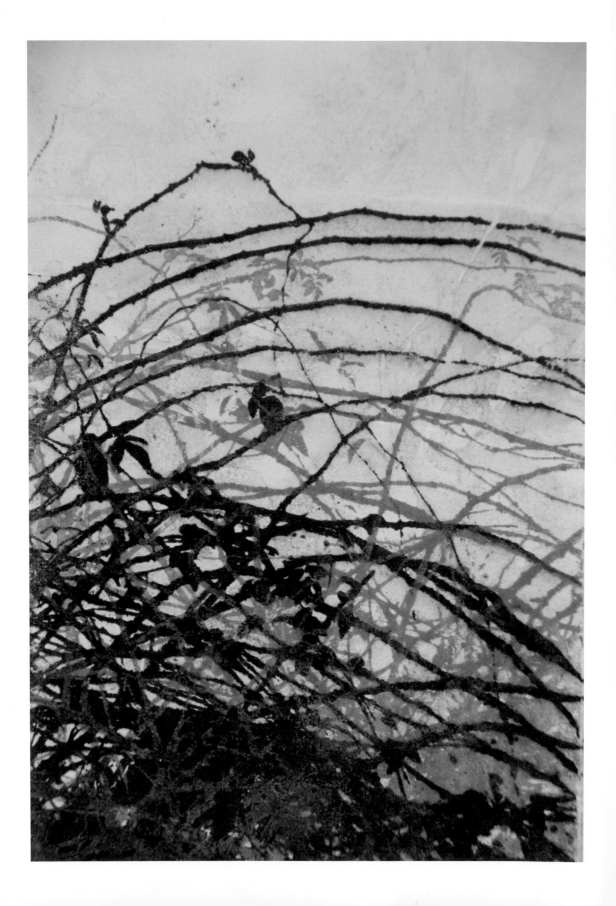

AN INTRODUCTION TO PAPER LITHOGRAPHY

Paper lithography is an accessible and flexible printmaking process with a grand title. It is often known by the term 'gum arabic transfer printing'. It is a printmaking process that simply relies on a toner photocopied image which can be transferred onto a variety of surfaces using gum arabic and oil-based ink to print with. At its simplest, it requires a photocopy which is covered in gum arabic, then inked with an oil-based ink and the ink is transferred to a substrate using a wooded spoon to burnish the back of the copy to release the ink.

The process allows me to work out ideas directly in my sketchbooks, as printing with paper lithography onto a paper substrate does not need a press. It is a technique that for me is a creative liberation; allowing me to experiment with ideas and enabling me to use photocopied images made directly from my own photographs and drawings. I can move from the idea stage in my sketchbooks, directly onto paper, developments in fabrics and as a resist to create etchings.

Inked up in two colours using a photocopied image from a photograph of fencing.

Opposite page: A two-colour paper lithographic print in an A2 sketchbook.

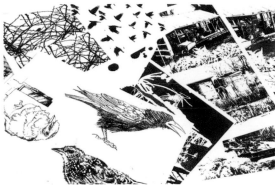

A pile of photocopies ready to print. Hand-drawn images and original photographs that have been made black and white have been photocopied here.

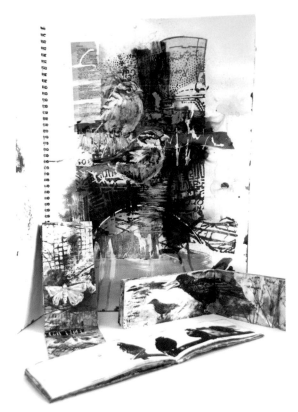

Playing with scale and using paper lithography as a key component in sketchbook work.

THE BASICS

What is gum arabic? Sometimes known as Senegal gum, Indian gum and by other names, it is a natural product consisting of the hardened sap of the acacia tree. It is harvested commercially from wild trees, mostly in the Sudan. Gum arabic is soluble in water, edible and used primarily in the food and soft drinks industry. It is also a key ingredient in traditional lithography and is used as the binding agent for pigments in watercolour paint.

What is lithography? It is a printmaking method based on the immiscibility of oil and water, immiscibility being when two substances will not mix. The technique was invented in 1796 by German author Alois Senefelder and was initially used to reproduce musical scores and maps. We are more familiar with the lithographic prints of Impressionist artists, such as Renoir, Degas, and Lautrec. The technique of lithography is still popular with artists today but does require studio space and extensive equipment.

Understanding that oil and water do not mix is the key to understanding the technique of paper lithography. Basically, paper lithography requires a strongly contrasted photocopy or laser printed image – such copies are printed using an oil-based ink. Inkjet prints are printed with water-based inks so will not be successful. I will explain how to achieve a suitable copy to print with in a later chapter.

HOW TO USE THIS BOOK

Paper lithography has become an important part of my creative practice. It acts as a starting point for many of my projects. I use my own photographic imagery to print backgrounds that I can then develop in my sketchbooks. I also print onto a variety of textile surfaces, both smooth cottons and more textured surfaces that are pre-stitched, loose woven or velvets that have a fluffy nap. I am also using paper lithography as a resist in etching as a safer alternative

to traditional methods that need solvents to remove the grounds. The process has many applications once mastered as a stand-alone technique or part of more complex printmaking and mixed media working practice.

I will outline how to develop successful photocopies of original drawings and photographs. I will describe the basic materials and equipment needed to get started, and what is required to advance the technique further.

There will be a step-by-step guide to making that first print and how to handle a larger format for the more ambitious projects that this technique will make possible. I will also cover in detail problems that may be encountered during the printing process and how to resolve them. I will demonstrate how paper lithography can be used as part of a mixed media art practice on paper, in sketchbooks and on a variety of textile surfaces. There will also be a chapter for printmakers wanting to explore paper lithography as part of an etching practice. Photocopied images can be transferred to metal where the oil-based ink will act as an etching resist to prevent the mordant biting into the metal plate, thus combining printmaking processes in hybrid work.

My aim is to demonstrate the flexibility of paper lithography, how it can be used effectively with basic printmaking equipment and little financial outlay. From the basics to using the technique in an experimental way as part of a mixed media practice on paper and textiles, to expanding its potential by using the process as a simple way of creating a photographic look to etching without the complicated chemicals. As a printmaking technique, paper lithography has a wealth of applications and the process is as accessible to artists new to printmaking as it is to those with an established printmaking practice.

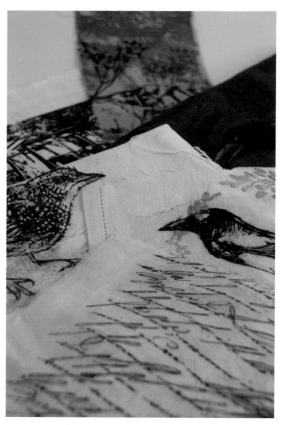

Printing onto fabric using paper lithography adds a further creative use for the technique.

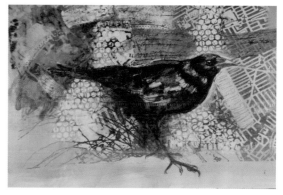

A work page from an A2 sketchbook using lithographic prints as a background starting point. Acrylic paint stencilled and washed with black Indian ink. The bird figure is drawn over the background and created using paint and ink in layers.

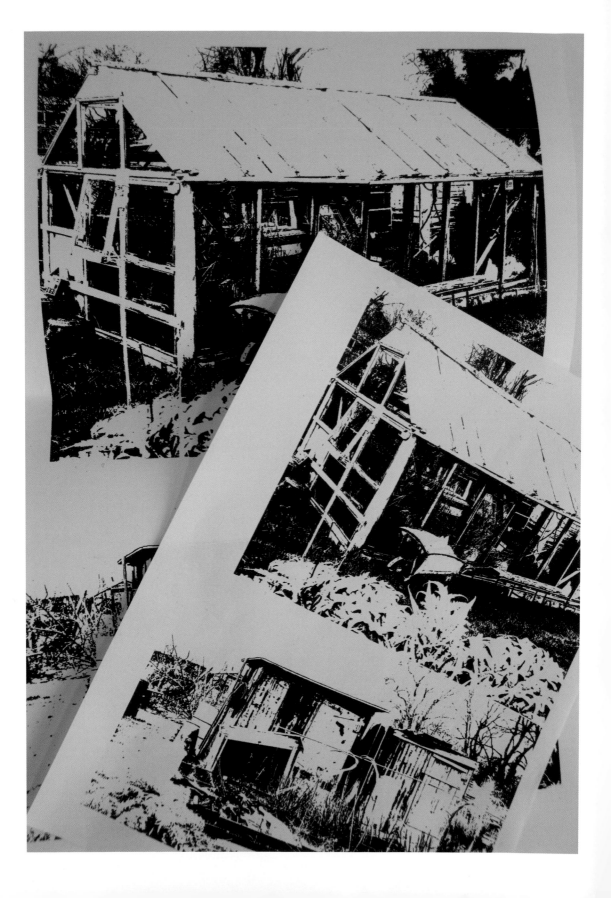

HOW TO MAKE THE RIGHT PHOTOCOPY

To make a successful paper lithography transfer print, there are a few basic concepts to consider: inspiration, design, and the technical processes. At this stage, the hardest thing is to decide what to make a print of, but for an initial experimental piece choose an image that is familiar so that all the other technical aspects can be concentrated on.

INSPIRATION

It has been said that inspiration is everywhere; it has to find you working. By this I mean just get started.

When trying a new technique, it is better to choose a simple image that has been used before, either a drawing from a sketchbook or an original photograph. It is possible to find copyright-free images on the internet. I personally like to use my own vision and make prints that are personal and original to me, especially when I am experimenting and even if the subject matter is universal.

Sorting out images to use for paper lithography is a great opportunity to look back through old sketchbooks and all those photographs stored on the computer. Choose something randomly that fits the criteria I will be outlining in this chapter. When the technique is mastered, it will be easier to sort out images that work well.

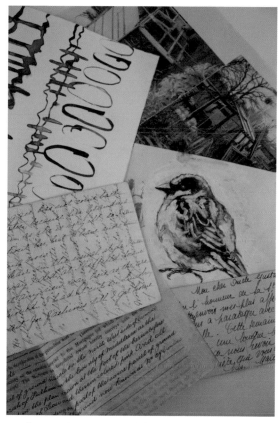

A collection of images suitable for making into black and white photocopies. This collection is made up of original drawings, doodles with ink and vintage documents. Remember that resources using text need to be flipped at the photocopy stage.

Opposite page: Black and white photocopies using original photographs of my allotment.

Images chosen for paper lithography, whether they are hand drawn or photographic, give a better result in the finished print if they are dramatically contrasting in tone. For example, a line drawing using strong black lines, large areas of white and no soft grey shading. Use photographic imagery that has been taken on a bright day with dark shadowed areas and strong light highlights, avoid an image that has greyscale areas.

Using first-hand images instead of downloaded resources from the internet will make it easier to resize, edit and manipulate the work for the next stage of image preparation. The ideal image is black and white, but fine detail prints beautifully, the image does not have to be crude and block like.

Of course, the starting point does not have to be figurative! Take a piece of white paper and make marks with black ink, a stick or nib pen. Use a marker and doodle or make patterns – the possibilities are endless.

Drawings or photographs do not always have to be the starting point; handwritten or typed messages or lists can look pleasing, either using an old typewriter or creating a document using one of the many fonts to be found on a computer. Handwriting has its own aesthetic and sometimes there is not much that needs saying, so creating imagery from asemic writing can be very satisfying. When it comes to the photocopy stage remember to ask for text to be reversed.

CREATING THE COPY

Once the images have been chosen, a toner or laser copy needs to be made.

Most people have inkjet copiers domestically. To make a paper lithograph print successfully, copies used must be printed on a laser printer or taken to a stationers to be photocopied using toner. A black and white drawing with no tonal shading can often be copied directly from its original source. A stationer will be able to photocopy black and white images but cannot turn coloured or greyscale images into the strongly contrasting black and white image needed for the process. I will explain how to turn greyscale into black and white later in this chapter. However, if presented with text they can reverse this as all text images must read backwards to print the right way round. Bear this in mind when having music, maps or well-known buildings photocopied.

Most imagery, both drawn and photographic, will need some extra work to create the black and white copy suitable for the photocopy stage. This can be done digitally.

I do not have Photoshop, but for those familiar with this package and who know how to use it, photographs, scanned documents and drawings can be manipulated to remove the greyscale from the image.

CREATING A BLACK AND WHITE IMAGE ON A COMPUTER

Everyone finds short cuts these days when working with computers. Many of us avoid using computers completely when trying to be creative. I admit to being a little computer shy, but I have never owned Photoshop so when manipulating images to make them completely black and white, both drawn and photographic, I use Word.

Having used Word documents for years it is the quickest and most comfortable way for me to prepare my images to be photocopied and I have been using this method since Windows 7. This method also works with a Word package on a Mac. There will always be exceptions and with a little trial and error, other ways can be found to remove greyscale from images using free downloads – it is a good reason to become acquainted with what can be done digitally on a PC, laptop and some phones. I like the idea of using a very basic digital method to create an image to be printed using analogue methods.

Original photographs can be used. Create a file of images that have good contrasting light and dark.

MANIPULATING IMAGES USING WORD

When using an original drawing, I scan and save it. If the drawing is larger than my scanner, I will photograph it with a digital camera and save the image.

1. With scanned or photographic images, the same method is used. Copy and paste the image onto a newly opened Word document.
2. Click left and select the image. A Photo Format flag will pop up in your tool bar at the top of your screen. Left click on that flag to open; a photo formatting tool bar will drop down.
3. Take a little time to see what is available in this tool bar. I find the cropping and rotating tools on the right of the bar useful. I crop out unwanted blank space and rotate so that I can fit a resized image onto an A4 paper size or copy several images onto a page.

Step 1: Copy and paste the image onto a Word document.

Step 2: Click on the image once in Word and a Picture Format instruction should appear in the top tool bar. Click onto this instruction to reveal more options.

Step 3: The Picture Format tool has many applications that are worth exploring. Cropping and resizing options are useful when trying to fit images onto a Word document.

Step 4: Move the cursor along the Picture Format tools to the Colour instruction and click on it to reveal a drop-down colour menu.

Step 5: In this drop-down section there is a choice of three black and white conversion options. Choose the one that will give the detail required in the image.

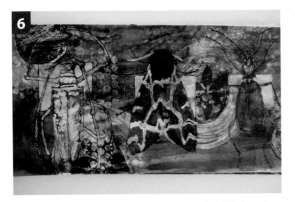

Step 6: A dark drawing that will produce a dark black and white image.

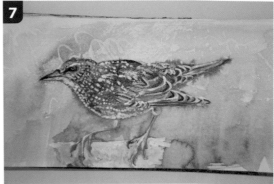

Step 7: A light drawing that will produce a light black and white image.

4. Once the image is cropped, look over to the left of the bar and find the Colour tool. Left click and an assortment of options will appear.

5. In the top row of the re-colour section on the far right, three black and white options will show. Hover over each image and the image on the Word document will change. Click on the preferred black and white version.

6. This method is all dependent on the tonal contrast of the original image. Too much grey and the tool may read it as black leaving no detail.

7. Too much soft line or pale in the image and the tool will read it as white, not leaving enough detail. When the image is complete, save it to a labelled file.

This method can be used on any image pasted onto a Word document. Print out the document and a suitable black and white image is ready to take to the stationers to be photocopied. I save my documents as PDFs and email them to my local copy shop.

There will always be one useful image out of the three offered. Click on the image that retains most detail and it will turn the coloured image on the Word document black and white.

DO NOT USE INKJET PRINTS

Remember that an inkjet printer will not work for paper lithography. Write 'Original' on the back of each inkjet printout so that if they get mixed up with the photocopies, they will not get used for printing. Better to keep them in a completely different folder.

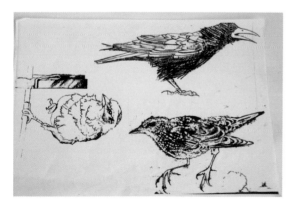

It is possible to cut and paste more than one image onto a Word document. This will always be more economical than one small image in the middle of an A4 page.

AT THE PHOTOCOPY STAGE

I try to fit as many images as I can on an A4 sheet of paper so that I am not photocopying blank paper. The paper used in the printing of copies should be basic; do not use paper that has been coated in any way to make it appear better quality. Cheap and thin works well – I use a 75gsm basic photocopy paper.

Get several copies made to allow for mistakes and experimentation. It is at this stage that I ask to have text reversed and have reversed copies made of figurative and abstract images. This often makes images look completely different.

While still at the photocopier, ask for a few A3 copies to be made. A range of sizes and larger sections printed together with a smaller counterpart can make for interesting imagery.

Most stationers can enlarge A4 images into A3 copies. Experimenting with scale can extend the creative possibilities of the technique. Also try collaging photocopies and photocopy the collage to create abstract images.

PHOTOCOPY PROBLEMS AND HOW TO SOLVE THEM

Image too light using the Photo Formatting tool

If using a drawing that has been made with a soft pencil or diluted ink, the scanner may not register all the marks. Rework the drawing using a darker pencil or going over lines with a fine marker and rescan.

If a photographic image does not produce the desired result with the colour tool, it indicates there is not enough black and white contrast in the image. Print the image out and draw in the details with a fine line marker, either rescan or get it photocopied. It may be easier to choose a different photograph that will give the desired result.

There is not enough detail in this image. However, detail can be drawn in using a fine line marker, combining photographic and hand-drawn imagery.

This image is densely dark. It could be used to print a light-coloured background for over printing. Or add detail using white acrylic or markers and re-photocopy.

Image too dark using the Photo Formatting tool

The colour tool does not always discriminate between tones and will read grey as black. If there are not enough white areas in the drawing or photograph the detail will be lost. Either choose an image with more contrast or draw white back into your printout with correction fluid. Be sure that this is dry before getting the printout photocopied. It may be easier to choose a different photograph that will give the desired result.

Unwanted marks on the photocopied image

When scanning original drawings or old documents there may be unwanted marks in the white areas. Check that the scanner bed is clean. The scanner may be picking up marks on the paper or with old documents, paper foxing and stains. Sometimes with old documents the colour of the paper does not read as white, creating unwanted black areas. These unwanted accidental marks can be used creatively or be painted out using correction fluid on the printout.

Photocopy machines can be very sensitive and pick up inadvertent marks on a drawing. Corrections made with white paint or areas erased may not be obvious, but these marks may show up on a copy. This can prove to be creatively interesting.

White lines running through the black areas of the photocopy

If the image has a dense area of black, there may be streaks of white on the photocopy in those areas. A large black area has challenges as a photocopier will read the information it is given; if the inkjet printout is unevenly printed in the black areas, the photocopier will also print it unevenly. The photocopier may be running out of ink or need servicing. However, a few white streaks in the copy will not show up when it is printed using the paper lithography technique. Always check the copy before leaving the shop.

A greyscale image

To make a successful paper lithographic print, the photocopy must be black and white. This is the instruction that is often interpreted. It can be assumed that a black and white image means just the absence of colour. It is clear from the example images below the difference between greyscale and black and white.

Some inkjet printers struggle to print large areas of black or lay down an uneven layer of black when the ink is running out. The photocopier will pick this up and will expand on pinhole white areas when the copy is enlarged.

It is important to have the right quality of image to produce the best possible paper lithograph print. The image above is black and white but is greyscale. The black and white image below will produce a successful print.

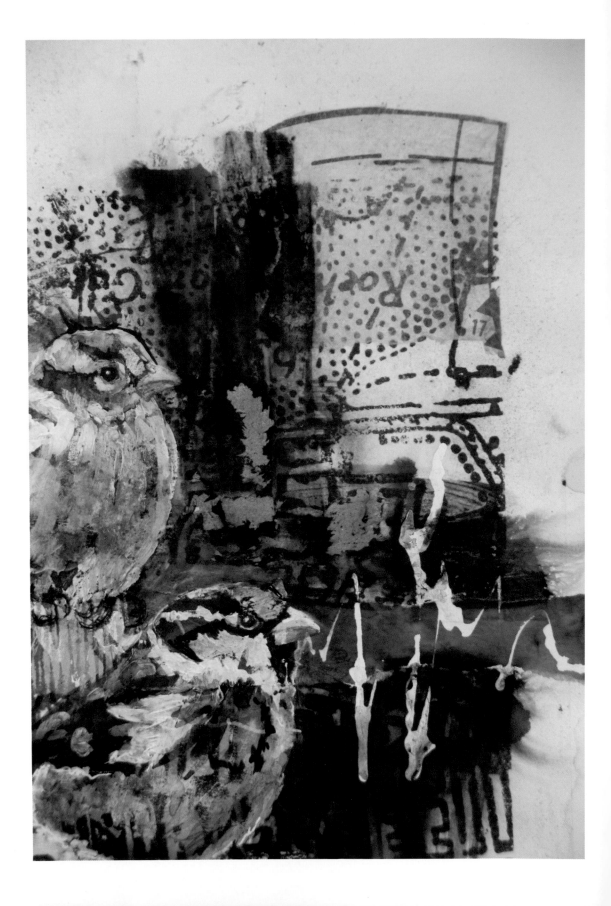

MATERIALS AND EQUIPMENT

The joy of paper lithography is that in its basic form it requires little in the way of specialised space, materials or equipment. It is possible to get started with just one ink colour, gum arabic, a roller and a wooden spoon. When I started to develop this technique, as an established printmaker I had all the required equipment to hand and although I have a studio space, I have been found printing on my dining room table, in village halls and conference rooms. It is possible to keep the ink contained, with care and planning. I like to call this a 'keeping it clean' strategy.

I make sure that everything is to hand before starting work to avoid trailing water and ink around between the different stages of the process.

EQUIPMENT

Most of the equipment needed to print your photocopy can be found around the house, in DIY shops and supermarkets.

Inking slab

This can be made of plastic or toughened glass. File cover plastic is a cheap and easily stored ink slab available at stationers. Plastic sheeting can be bought in DIY shops and cut to size with care using a heavy-duty craft knife against a steel ruler. Some printmakers use old fridge shelves, but most smooth surfaces will work.

Just make sure the surface remains in one place to allow ink rolling and consider using a slab per colour to save on cleaning between printing different colours.

A garden spray bottle

Spray bottles are easily obtainable; it is best to get a sturdy one as a powerful spray makes the process faster. This is an item where the more costly it is the longer it will last. The cheapest bottles may not stand up to continuous use for any length of time.

A wooden spoon

This item is often tucked away in most kitchen drawers, but do not use it domestically after printmaking. However, a baren can also be used, another low-tech piece of equipment used to burnish the back of paper when block printing.

A bucket lined with a plastic bag

As part of the inking process there will be wastewater that carries ink residue. As part of the 'keeping it clean' strategy and to keep oil-based ink from spreading around a sink or going down the drain, the bag catches the waste ink separating it from the wastewater. The inky bag can be thrown away at the end of the printmaking session.

Deep-sided tray

Again, this is a part of the 'keeping it clean' strategy. I use a new cat litter tray with high

Most of the equipment required for paper lithography will be easily acquired. Rollers will need to be purchased from a specialist supplier, but it is possible to start with a cheaper roller when starting out.

sides. It will contain the inky residue avoiding contaminating work surfaces. The tray can be easily cleaned after each printmaking session and reused.

A roller

This will involve a trip to an art shop. Good-quality rollers are lovely to use but are quite expensive. However, try a cheap roller first, it will be adequate for initial experiments. The crucial part of this piece of equipment is that the roller surface is smooth and clean. The bigger the photocopy, the bigger the roller needed. Trying to ink up a large photocopy with a small roller will lead to tramlines in the inked surface. This may be the desired look required from the resulting print, but can be distracting.

Palette knife

A palette knife per colour will save on cleaning mid process.

MATERIALS

By materials I mean consumable items that will need to be replaced as they are used up. Most of these will need to be sourced from a printmaker's suppliers. There is a list of suppliers at the end of the book.

Oil-based ink

Most traditional oil-based inks will work, particularly etching ink. It is worth trying oil paint if that is available, but this might not give such a strong, clear print. At all costs do not use water-soluble or Safe Wash inks for the same reason an inkjet print will not work. Despite the oil content in these inks, they are designed to wash off with water and will not successfully resist the gum arabic or stick to the photocopy image. Paper lithography relies on the immiscibility of oil and water and Safe Wash inks do not allow this to happen.

Gum arabic

Gum arabic can be found in two forms – premixed and crystals. Both are available from most good art suppliers. I prefer my gum premixed; this guarantees its reliability. Often there will be a bottle of gum arabic in a pile of neglected art materials from previous projects. Check its consistency, it may need diluting or even replacing.

Linseed oil

Linseed oil can be sourced in DIY stores. Printmaking suppliers have copper plate oil which can also be used. It is used for diluting the ink so is a crucial component.

Non-stick baking paper

This can be found in the baking aisle of the supermarket. Be aware that greaseproof paper is much thinner and will buckle and crease if used.

Blotting paper

As a printmaker I use large amounts of blotting paper when I print my collagraphs and use old, ripped blotting for paper lithography. These off-cuts are used repeatedly. Blotting paper can be sourced from most good printmaking or paper suppliers. But if difficult to find, try a J-cloth – it works just as well and can be used repeatedly if dried out between uses.

Newspaper and glossy magazines

Have plenty of old newspaper to hand to cover working surfaces and use when cleaning up at the end of the printmaking session. It is easier to cover up stray ink than to continually wipe working areas down. Glossy magazines make an excellent inking pad. The surface allows for a gentle give when rolling ink onto the photocopy.

Cooking oil and T-shirt material

At the end of a printmaking session, surfaces and rollers must be cleaned. Cheap cooking oil is effective and a nontoxic alternative to white spirit, and together with cotton jersey rags that absorb the oil while cleaning, is the most efficient way to clean up.

IN PREPARATION

Each piece of equipment and all the materials are required to make a successful paper lithography print. Once the first few prints have been made, this is the time to experiment with different inks and items of equipment. There will, of course, be things that can be substituted, and personal adaptions can be made after becoming familiar with the process.

Scale does not have to be a limitation, although to begin with it is best to practise the process with A5 photocopies. Once confident in creating lithographic prints in this way, progression can be made onto larger photocopies. A3 prints can be made using larger rollers and suitably sized Perspex sheets to ink the copy onto. This will be explained in Chapter 4.

Before printmaking commences, I prepare everything I need. Have to hand a pile of photocopies and the sketchbook or paper surface to be printed onto. For me, this stage is a bit like cooking; I get all my materials and equipment ready. The plastic bag in the bucket, fill the spray bottle with ordinary tap water and mix the ink.

It is now that I will choose the substrate I will print onto. Hand-printed paper lithographs work most successfully on smooth surfaces. A good-quality cartridge paper can either be in sheet form or in a sketchbook. The thicker and better-quality papers cope well with the initial wetness of the photocopy when transferring the print. However, most papers will cope with being printed onto in this way and each will react differently. A cheaper paper may absorb the moisture and take a longer time for the dampness to dry, leaving a water mark. It may also buckle slightly when wet, but this can look attractive and give a vintage feel to the print when dry.

Brown paper or other specialist papers often have a matt side and a coated glossy side. Paper lithography will print on either surface, but a shiny substrate will take longer to dry and tend to smudge when touched for a considerable time after printing.

Tissue paper can also be printed onto, creating translucent papers ideal for collaging with. It is easier if a wet strength tissue is used or at least a good-quality tissue. It will require a gentle touch when printing as tissue paper is delicate when wet, but well worth the effort.

Beware of textured surfaces. When hand-printing paper lithographs the print will echo the surface it is transferred onto. For example, if an image was printed onto corrugated card the ink of the photocopy plate would only touch the raised areas breaking up the image, thus making the image hard to read. This is an extreme example, but textured watercolour paper or chunky hand-made papers will disrupt the image. This of course can make for creative opportunities, and I would always urge experimentation with a variety of substrates.

GETTING STARTED

I never lose the sense of anticipation when I am about to start a printmaking session. This is heightened by the activity of sorting out photocopied images ready to print with. I will often use the process to give my creativity a kick-start by filling up sketchbook pages randomly with paper lithographic prints. I find a pre-started page more inspiring to work into than a pristine, blank piece of paper. A random print will often dictate the direction the project may proceed in later or be a nice surprise in a sketchbook when out drawing.

Allow a reasonable amount of working time to the activity of printmaking. Set aside some time to experiment, a couple of hours at least as this makes the setting up and clearing away worthwhile. As a rule of thumb, I will make sure that I am printing for longer than it will take me to get out the ink and clean away the rollers.

Printmaking in any form needs some organisation to contain stray ink and achieve a successful clean outcome. With that in mind, collect all the equipment and materials needed and lay them out in a logical order. Consider how much space there is to work in and cover all working surfaces with a layer of newspaper to keep surfaces ink free.

A sink is not essential once the spray bottle is filled, but access to a drain or sink will be useful at some point to empty the bucket and refill the bottle from time to time. With a little ingenuity and forethought, awkward issues can be overcome.

PREPARING THE WORKING AREA

Lay out your equipment in process order. From left to right:

- A sheet of baking parchment to apply gum arabic to the photocopy
- Magazine to ink up on
- Ink slab and roller
- Tray
- Lined bucket and spray bottle
- Receiving surface

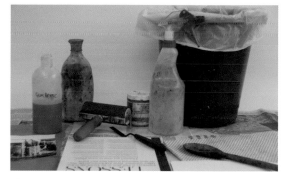

All materials and equipment gathered before starting to print.

Opposite page: A page from an A2-sized sketchbook, using paper lithography as a starting point.

PREPARING THE INK

With everything to hand, a pile of photocopies ready to go and the receiving surface for the print considered, now it is time to get the ink ready. I will again emphasise the ink used for paper lithography must be oil based and not a Safe Wash ink.

To save time and to preserve the creative flow, it is best to get at least two colours mixed and ready to use.

Place a quantity of ink at the top of the ink slab with a palette knife.

Drip linseed oil into the ink a little at a time, mixing in well with each addition. The ink should drop off the palette knife in a blob. If the ink stays stubbornly on the knife, it requires more oil. Too runny will mean that more ink needs to be added to the mix. I always decant my linseed oil into an old washing-up bottle. This means that I can control the amount of oil I add to the ink. Clearly label the contents.

Make sure that the ink is well mixed with the oil and there are no neat lumps of ink in the mixture. Unmixed ink rolled onto the photocopy will not spray off.

It is not the end of the world if the ink is too runny or too stiff. Different inks require different amounts of linseed to get them to the right consistency. There is no set formula. Mix up a colour then try it out – it will quickly be apparent if the ink needs adjusting. With experience and regular printing, it will be obvious when the ink is the correct consistency. Different pigments will react in startlingly different ways. It will then be a matter of choosing the effect required from the print.

Make a note of what is being used and how much linseed is needed to get a particular ink to the right stage. This will be helpful when coming back to printing with it again.

Ensure that the linseed oil is completely mixed into the oil-based ink.

There is too much ink rolled out on the roller and ink slab, which gives it an orange peel texture.

The correct quantity of ink on the roller and ink slab should have the look of suede and make a soft "shushing" noise.

APPLYING THE GUM ARABIC

Lay the photocopy image side down onto a sheet of baking parchment. Apply a small amount of gum arabic and smooth it evenly across the back of the copy using a flat hand.

Do not work the gum arabic into the paper; just smooth it over the surface, covering it completely up and off all the edges.

Turn the copy over and repeat the process on the printed side. The copy should be completely wet, but not with pools of gum on the surface. Take the gum to the edges, especially where there are large areas of white. The ink will stick in white areas that are not covered in gum arabic.

It will be possible to see the gum resist the photocopy ink, forming droplets on the surface.

Pick up the copy and let the excess fluid drain off back onto the baking parchment.

Apply gum arabic to the reverse of the photocopy, ensuring complete coverage.

Cover the front of the copy with gum arabic, taking it to the edges. The copy should appear wet.

Photocopy ink resists the gum arabic and it will appear to pool on the ink of the copy.

Allow the excess gum to run off the corner of the copy onto the baking parchment.

INKING

Apply the prepared ink onto the copy with a roller. Roll gently and repeatedly apply thin layers of ink.

Lay the gummed copy onto the glossy magazine, image facing up. The black of the photocopy should be clearly repelling the gum arabic in droplets.

Roll one way from the middle to the outer edge to avoid the copy picking up and rolling around the roller.

Recharge the roller with ink from time to time and repeat the inking up of the photocopy.

The photocopy should be covered in a thin, even layer of ink. If areas of black still appear through the ink surface, this means there is not enough ink covering the photocopy.

Gently apply more ink to that area. When using a roller, roll lightly on both the ink slab and the copy. Ink adheres to a roller and the photocopy more effectively if a light rolling action is used.

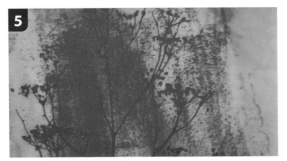

The ink should be applied evenly to the roller ready to apply to the copy.

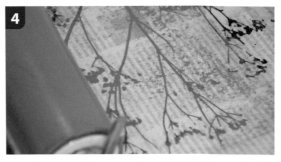

Starting from the middle of the copy, roll in one direction across the copy.

Starting the roll from the edge will result in the copy wrapping around the roller.

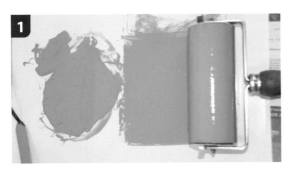

Cover the copy with an even layer of ink. The image should still be visible, but the black copy ink covered.

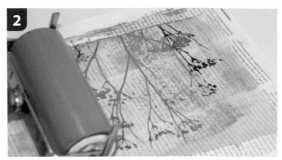

With the inked copy placed in a tray, spray with water.

REMOVING INK

Place the inked copy into the tray and hold the tray over the bucket. The tray sides prevent the inky loaded water spray coming off the copy, covering clean surfaces. Using a garden spray bottle filled with tap water, spray the copy starting at the top and work down. Keep the spray nozzle close to the copy without touching it.

Make sure the bottle is on spray. A strong single jet will blast holes into the photocopy. If the spray is not strong enough and the ink is not moving off, try filling the bottle with more water.

As the copy is sprayed, the gum arabic dissolves from the white areas, which takes the ink with it as it runs off the copy. The oil-based ink is left on the surface of the photocopy image.

Stop spraying when either all the ink has been released from the white areas or the required look is achieved. Ink will not come off the photocopy ink image, even with repeated spraying.

Some pigments create a monoprint look to the image; other pigments such as metallic inks wash off cleanly and create a crisp image. With experimentation it is possible to achieve different inking outcomes.

The gum arabic will dissolve taking the ink in the white spaces with it.

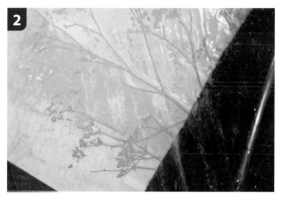

Ink will be left on the black photocopy image. Prolonged spraying will not remove it.

Continued spraying will release ink around the photocopied image.

The copy is ready when the desired amount of ink has been removed.

PRINTING

Take the inked and sprayed copy out of the tray carefully as wet photocopy paper is delicate.

Place the copy inked side down onto the chosen substrate. Avoid dragging the copy across the surface as the ink releases as soon as it meets the paper. Cover the copy with a piece of blotting paper and rub across the blotting paper firmly with a wooden spoon.

Pull back the blotting paper and gently peel back the copy to reveal the print. It is now possible to over print in another colour or work into the print without waiting for it to dry.

For the best results use each photocopy once and discard after printing. However, this is a moment to experiment with reprinting used copies.

There are many stages to the process, which leaves several opportunities for mistakes to be made or the print does not live up to expectations due to the way the ink is applied. Practice does make perfect, and the more time taken experimenting with paper lithography will lead to results that can be repeated, and the quality of print can be guaranteed. However, it is easy to miss out a stage – here are a few examples of typical problems that arise and the reasons they occur.

Handling with care, place the wet copy ink side down over the receiving surface.

Cover with blotting paper and apply pressure to the reverse of the copy.

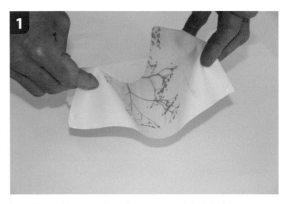

Peeling back the photocopy will reveal the released ink.

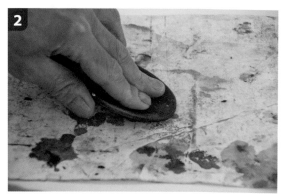

A sample photocopy to demonstrate problems with the printing process.

1. This is the photocopy inked up and printed showing no problems with either of the techniques employed.
2. It is easy to get inkjet and photocopies mixed up and it is often not obvious that the wrong one is being used until after printing. Inkjet prints will not work for this process.
3. When applying the gum arabic, ensure that the copy is completely covered. Any areas that are missed will attract ink. Keep your fingers closed when applying the gum.
4. The texture of the ink is important; if there is not enough linseed in the ink, the copy will not spray off properly. Add more linseed to the ink to slacken it off.
5. It can be easy to put too much linseed into the ink, making it too runny. This results in the ink bleeding around the print. Add a touch more ink to the mix.
6. Using the right-sized roller for the size of the photocopy is important. If the roller is too small and too much pressure is applied, roller marks will appear on the print.

Step 1: A successfully inked up and printed photocopy, where inking is even.

Step 2: The copy must be laser; an inked-up inkjet print looks like this.

Step 3: Unevenly applied gum arabic where the ink sticks to white areas.

Step 4: Not enough linseed making the printmaking ink too thick.

Step 5: Too much linseed oil added to printmaking ink, making it spread.

Step 6: Using a small roller on a larger copy, leaving roller marks.

7. Rolling the right amount of ink onto the photocopy is the key to a successful print. Too much ink will lead to the loss of delicate detail.

8. If not enough ink is applied to the photocopy, the subsequent print will look faded. However, a softer look may be the desired effect.

9. More haste means less speed at the spraying stage. It is important to have the bottle set at a strong spray setting, but too direct and the water will shoot holes in the copy.

Step 7: Too much ink applied to the copy and the detail will be lost.

Step 8: Not enough ink applied to the copy makes it faded and pale.

Step 9: The wrong setting on the spray bottle can damage the copy.

10. Spray the copy vigorously to remove all the ink from the white areas. Leaving ink on selectively can be a creative decision.

11. Position the inked copy positively. Once the ink surface touches the receiving surface, the ink will release. Trying to reposition will cause drag marks on the paper.

12. When transferring the print, even rubbing on the reverse is essential. Work the back with rounded even strokes – quick, rushed rubbing leads to marks on the print.

There is a very fine line between being happy with the accidents created by the spontaneous results of printmaking and technical errors in applying the technique. It is interesting to see how many of the technical glitches that appear here might also prove to be interesting surfaces in further creative work. Understanding how the ink reacts when applied in different amounts across the photocopy or pressure is varied when printing the copy can help to make informed decisions when making work with paper lithography.

Step 10: Leaving ink in spaces can be a creative choice.

Step 11: If the copy moves when printing the image will blur and leave marks.

Step 12: When printing, rub the reverse of the copy evenly to avoid leaving lines on the print.

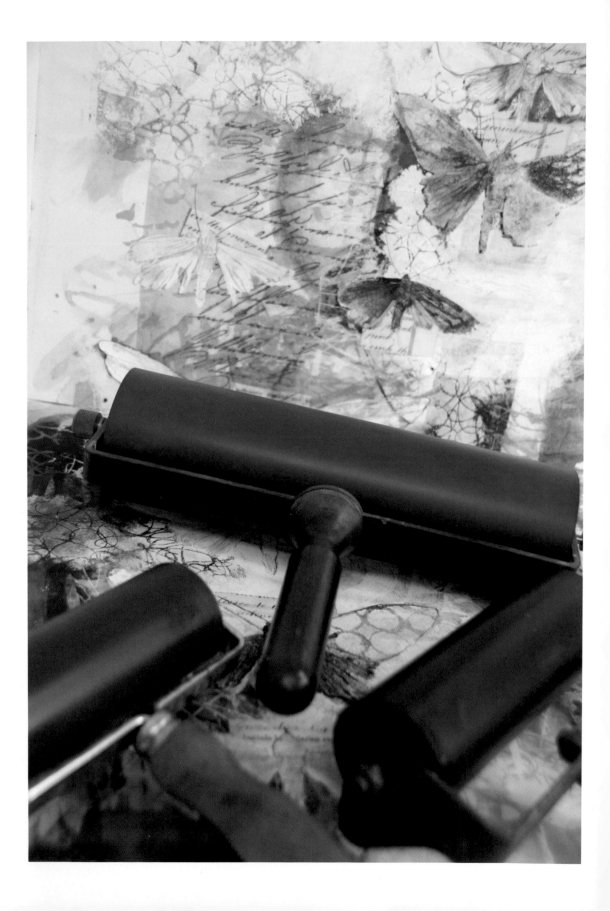

HANDLING A LARGER IMAGE

Once the technique of printing paper lithography has been practised, it will become easier and take less time to produce successful prints.

These prints can be added to mixed media projects or used as the starting point to sketchbook pages. When the inked photocopies are dry, together with the prints they can be a valuable addition to a collage project. There will soon be a useful pile of small, printed papers that can be used as a creative resource. With the technique mastered little needs to be altered with the process to make work using A4–A3 photocopies.

It is a good plan to experiment with a differing scale of images, and creating A3 copies can add variety to work.

But making larger prints takes more space and larger equipment.

The previous printmaking instructions have limitations for printing A3 photocopies. Baking parchment can be bought in rolls giving length, but the width is standard and will not accommodate an A3 photocopy. Inking up on a magazine pad also limits the size of the photocopy that can be used. If the copy hangs over the edge of the magazine, an inked line will appear on the copy that will not spray off.

The materials and equipment for printing a larger photocopy are basically the same, but the strategy to ink up and print needs to be altered

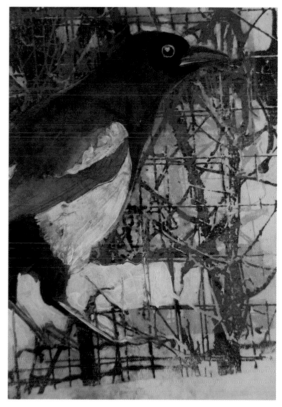

Image using an A4 paper lithography layer as a background to a mixed media magpie drawing.

slightly to create a successful print and accommodate the larger-sized copy.

Wet photocopy is tricky to handle on a large scale. It is best to limit the handling of a wet copy as the paper becomes fragile after gumming and spraying. Keeping the larger copy in one place when inking avoids damaging it by

Opposite page: Several larger rollers to print larger photocopies.

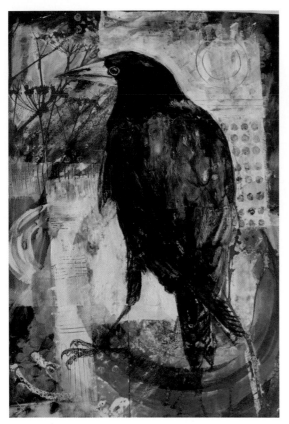

A2-sized image using paper lithography layers as a background to a mixed media crow drawing.

Layers of A3 lithograph prints as a starting point to a sketchbook page.

over handling. An A3 copy is hard to manipulate when wet due to both its size and weight, so the following method will make printing a large copy easier.

Before starting to print, create space and time to make a larger piece of work. Set out a working area as previously suggested and prepare the ink as for smaller prints. Mix up more ink as it will need to go further. More space will be required to fit in a large photocopy and a larger receiving surface and have plenty of working room to ink up and lay down the wet print. It is important to have everything ready before starting to print. This altered strategy to deal with an A3 photocopy will ensure complete coverage of the copy by the gum, avoiding unwanted ink lines in the finished piece from the edges of the magazine. The baking

parchment and magazine inking pad will not be needed for this process.

EQUIPMENT AND MATERIALS

A large roller
To successfully ink up an A3 copy means that all the equipment needs to be scaled up. Invest in a larger roller. It is possible to use a small roller, but it will be harder to ink up the copy evenly and without roller lines across the image.

A piece of plastic
A piece of plastic sheet that will comfortably fit an A3 photocopy. This plastic sheet will be used when applying the gum arabic and will be where the copy is inked up.

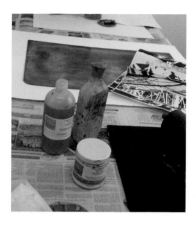

Lay out the materials and equipment ready to make the larger images.

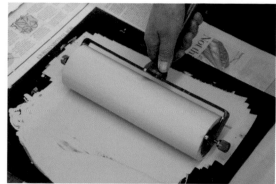

Prepare the ink with linseed oil and ink up a larger roller to accommodate the inking of a larger copy.

Spray bottle filled with water
It is important to have the bottle full as it will spray with more power and a greater length of time than when half full.

A3 sheet of blotting paper or J-cloth
An absorbent flat surface that will not leave marks in the surface of the print.

Wooden spoon
Firm, even contact needs to be applied the back of the print to push the ink onto the receiving surface. The larger the wooden spoon the better or a baren would work well.

Bucket lined with a plastic bag
This is still possible to use, but it will need balancing skills. A sturdy heavyweight bucket or large plastic bin would work better. But if the receptacle is lined with plastic, it will be easier to clean.

Receiving surface
This could be any paper surface or sketchbook.

A3 black and white photocopies

Absorbent cloth or paper towel

Blotting paper
The appropriate scale for the copy being transferred.

PREPARING THE INK

Prepare the ink as previously suggested. It is advisable to mix a reasonable amount of ink when working with larger images and bigger rollers. It would be awkward to run out of ink mid-way through printmaking, as it's then difficult to ensure a consistency in the mix of the ink.

Lay the A3 copy image-side down onto the piece of plastic and apply gum arabic to the reverse.

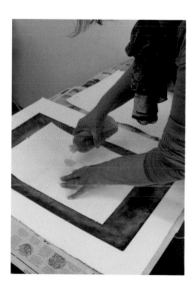

APPLYING THE GUM ARABIC

1. Lay the photocopy image side down onto the plastic sheet. Apply the gum arabic to cover the copy. Work swiftly, smoothing out wrinkles and air bubbles in the copy.

 Smooth it evenly across the back of the copy using a flat hand, completely covering it. Work the gum off the edges of the copy.

2. Carefully turn the copy over ensuring that the copy is wrinkle free and smoothed onto the plastic. Repeat the gum arabic application process on the printed side. Again, spread the gum into the surface. Do not massage the gum arabic into the paper as this will weaken the surface.

3. The gum should cover the whole copy to the edges and over all the white in the image. The surface should look wet in the white areas of the copy and the gum will pool off the black ink. The photocopy should not appear translucent.

4. With an absorbent cloth or paper towel, wipe away excess gum off the plastic around the photocopy. This will make the inking stage easier to manage. If there is too much gum on the surface, the ink will not attach to the photocopy ink.

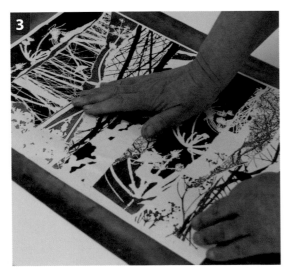

Step 1: Spread evenly to the back of the copy.

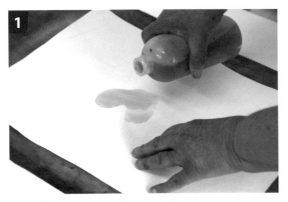

Step 2: Turn the copy over and apply gum arabic to the front of the copy.

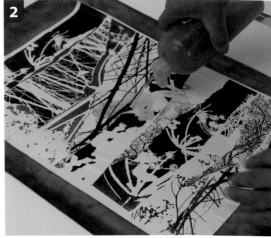

Step 3: Spread the gum arabic across the front of the image, covering evenly.

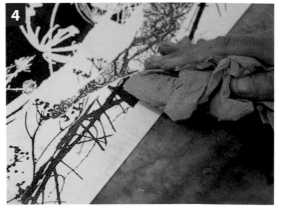

Step 4: Wipe away excess gum arabic from the surface of the plastic around the edge of the copy.

INKING

Leave the gummed copy on the plastic sheet and ensure there are no wrinkles or creases in the paper copy. Apply the prepared ink onto the copy with a roller. Roll gently and repeatedly, applying thin layers of ink. Roll one way from the middle to the outer edge to avoid the copy picking up and rolling around the roller.

Do not press down hard with the roller. Stroke it across the surface; the ink will want to come off onto the copy without pressure. Recharge the roller with ink from time to time and repeat the inking up of the photocopy. If continuous rolling takes place without re-inking the roller it will start to take ink off the copy, which is counterproductive.

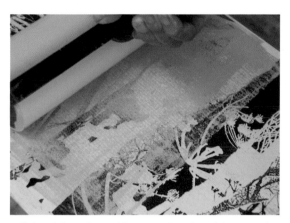

Roll the ink from the middle out to the edge of the copy. The roller should be a similar size to the copy to avoid rolling lines.

Indigo Stay Open Etching ink with linseed oil added ready to ink up a photocopy.

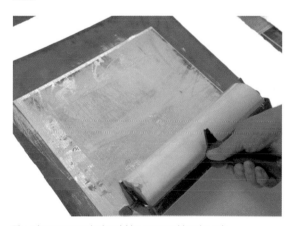

The photocopy ink should be covered by the ink.

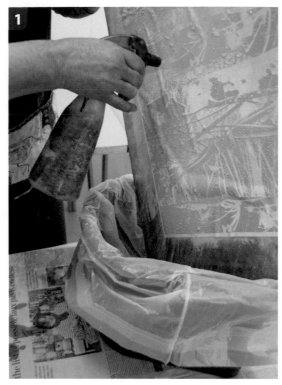

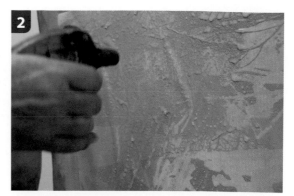

Step 2: The ink should release from the white areas of the copy as the gum arabic dissolves with the water spray.

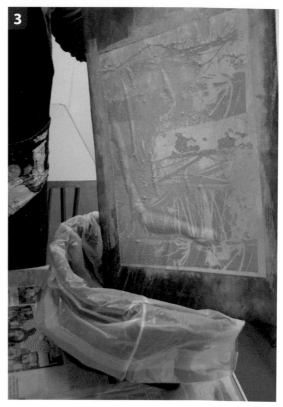

Step 1: Pick up the plastic and position the corner into the bucket. Spray with the water starting at the top of the copy working downwards.

REMOVING INK

1. Take the plastic sheet together with the attached inked copy to the bucket. Place the corner of the sheet into the bucket, to allow the water to run off the copy into the bucket. Using a garden spray bottle filled with tap water, spray the copy.

2. Spray from the top and work down. Keep the spray nozzle close to the copy without touching it, as the water needs to hit the ink with some force. Hold the bottle too far away and the ink will take more effort to remove.

3. Stop spraying when either all the ink has been released from the white areas or the required look is achieved. Ink will not come off the photocopy ink image even with repeated spraying. Some inks will bleed back into the white and add to the print.

Step 3: Continue spraying until the required effect is achieved, allowing the water to run off into the bucket.

PRINTING

1. Lay the plastic sheet down next to the receiving surface. Be aware that ink-loaded water will drip onto clean surfaces off the print and will make inky marks on clean paper. The more the copy is sprayed, the less chance of inky run off.
2. Lift the wet photocopy off the plastic sheet and hold the copy by opposite corners. Handle the wet paper with care. Position it so that the middle of the inked copy will contact the receiving surface. Consider the position of the print before handling the copy.
3. Manipulating a piece of large, wet photocopy paper is a delicate operation. The weight of the wet paper can easily tear the corners by which it is being held. A confident approach to placing the copy is needed. Work gently but without delay.
4. Gently lay the copy from the middle onto the receiving surface followed by laying down each side. When the copy meets the receiving surface, it will release ink. Once the copy is down, it is done and can't be repositioned without leaving ink behind!

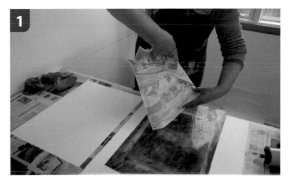

Step 1: Lay the plastic down next to the receiving surface and carefully pick up the wet inked copy.

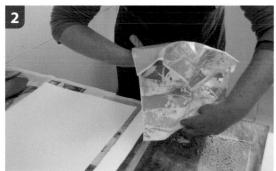

Step 2: Holding the edges of the copy, carefully manipulate it and position it above the receiving surface.

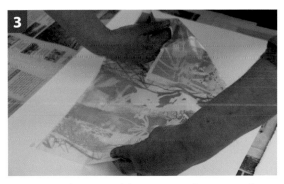

Step 3: Drop the centre of the copy onto the paper and lower the edges down gently.

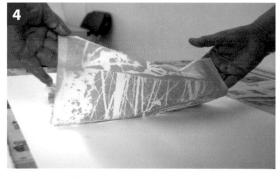

Step 4: Gradually lay down the inked copy from the centre out to the edge of the receiving surface.

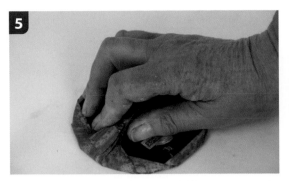

Step 5: Cover the back of the copy with blotting paper and gently burnish the reverse.

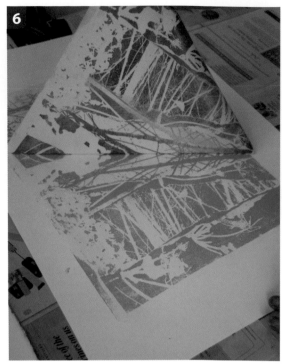

Step 6: Gently peel back the copy to reveal the print.

5. Cover the back of the copy with blotting paper or a J-cloth and rub evenly across the copy with a wooden spoon or baren. A clean roller could be used, but this does not always apply direct even pressure to the back of the copy.

6. Pull back the blotter and then the copy to reveal the print. To check for even pressure take a sneaky peak before taking the copy off completely. Lay the copy back down and rub again to even out the ink off the copy.

It is possible to work straight into this print with another lithographic image, layering other colours over the top without waiting for work to dry. It is also possible to paint acrylic over it or wash inks into the image. It is an adaptable process that does not require patience waiting for surfaces to dry before further development. However, if filling sketchbook pages to create starting points is the plan, interleave magazine paper between wet printed pages to avoid unwanted ink transfer onto clean surfaces. These pages will be dry enough to uncover in a couple of days.

Printing larger paper lithographs is well worth the effort. It can be daunting trying to manipulate a large, wet photocopy, but practice makes perfect. Handling the copies with confident care and preparing the workspace to accommodate copies from A4 to A3 will lead to interesting and creative results.

Layering up images of varying scales will extend possibilities and make dynamic prints.

GHOST PRINTS

Once the first print has been pulled there may be enough ink on the photocopy to take another. Lay the copy image side down on another surface and take a ghost print. This will be lighter and have the faded quality of the original image. If the original was over inked, it is a good way of getting a successful second print without having to re-ink the copy.

A completed A3 paper lithographic print in Prussian Blue.

CLEANING UP

Printmaking can be a messy business and the cleaning of oil-based inks can be off-putting before even starting to get inks out and printing. Getting into a routine is the best policy and understanding the nature of the materials is crucial to the 'keeping it clean' strategy.

If any ink has migrated onto a work surface that is covered in newspaper, it makes the cleaning away far simpler than if surfaces are not covered up with paper. Having clean hands when handling ink-free materials and equipment is obvious, but important. Being aware of stray ink that may have escaped during the printing process will stop work being contaminated – catch it before it travels is my motto.

Here are four simple steps to cleaning up after a printmaking session that will keep the worst of an inky mess contained.

1. Put away any materials that you don't need and all ink-free equipment before starting to clean. Ensure all fresh prints are safely out of the way too. Do this with ink-free hands.
2. Scrape off excess ink from ink slabs and dispose of it. Roll excess ink off the rollers onto spare newspaper. Removing excess ink this way makes the cleaning up easier. Remove all inky paper and place slabs and rollers onto clean newspaper.
3. Pour cooking oil onto inked surfaces and rollers. Using T-shirt rags, rub the oil and ink off the surfaces. Start with the rollers as they are fiddly to clean. Check that the edges are ink free. Go on to clean up the ink slab and palette knives – I always leave the easiest things to clean last. Wipe off excess cooking oil from rollers and slabs with clean rags.
4. Rollers and slabs can now be wiped off with hot soapy water to remove the oil. This is not completely necessary, but it will remove greasiness if it is unwanted.

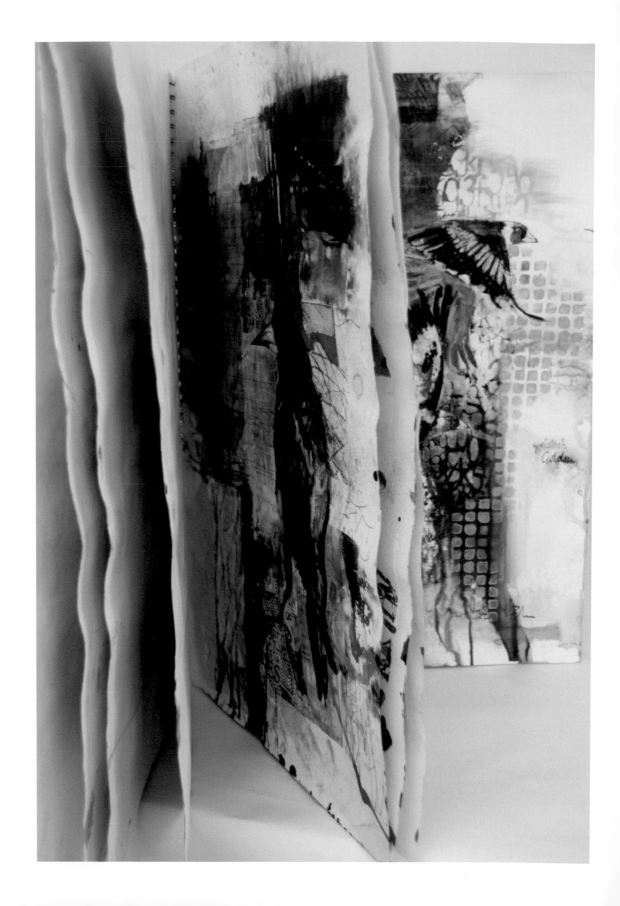

PAPER LITHOGRAPHY AS PART OF A MIXED MEDIA PRACTICE

In this chapter, I describe how paper lithography can be used as part of a mixed media practice. Exploring this flexible printmaking process and combining it with other media can develop ideas and lead to a piece of stand-alone work. I describe the processes, materials, and equipment I use to develop a visual idea which can be made on a piece of paper or in a sketchbook.

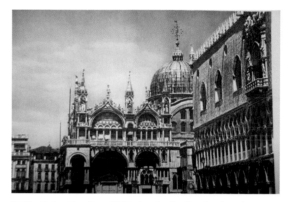

St Mark's Basilica from 1930s book of Italian landmarks.

SKETCHBOOK PRACTICE

I have been exploring the creative possibilities of paper lithography since 2007 when I started to use it extensively as a technique in my sketchbook practice. At that time, I had been invited to be an artist in residence for a local school and to accompany the sixth form on an 'A' level art trip to Venice. I was employed to inspire the students to produce creative sketchbook pages about their Venice visit as part of their exam course work. It occurred to me that my artistic expertise was in the drawing and collagraph printmaking of birds and that Venice is predominantly known for its wonderful architecture. I have never had the patience to draw buildings, so I realised I had to find a creative way into this project. It was the lucky find of a 1930s photographic travel book in a charity shop with a chapter on Venice, coinciding with

my experiments with paper lithography, that inspired a new direction in my work.

The images of Venetian buildings in the book enabled me to create black and white photocopies of architectural features to pre-start pages using paper lithographic prints. I was able to make copyright-free images from the book to start my example sketchbooks. Modern-day Venice looks much the same as 1930s Venice – there are now just more people and pigeons than ninety years ago.

Paper lithography has been a pivotal part of the work I do in sketchbooks since that week away in Italy, and I nearly always start a drawing project by laying down a series of lithographic prints onto blank sketchbook pages. For many people it is the fear of the blank page that stops the initial creative start, especially with

Opposite page: A2 mixed media sketchbook. Pages full of layered paint, ink and print.

a brand-new sketchbook, so having a positive process to start a project can get most people over that initial artistic block. I use sketchbooks as a catalyst for ideas, starting a page, working into it with layers of print and drawing, sometimes as an end point or a stepping stone onto another idea.

Sketchbooks showing paper lithographic starting points for the school Italian trip.

Sketchbook and image source from Italian trip.

I have several sketchbooks that I work on at the same time and these books will have different purposes.

My experimental A5 book will fit neatly into my handbag or is always to hand around the house. This book is for jotting down ideas, taking on-the-spot visual notes or doing small experiments in. I will always have several paper lithographic prints scattered through it at random to make the book feel used. Having a lithographic print here and there throughout the book helps me to lose that precious feeling about a quick drawing of a rough idea, especially if it is not my best work. Having a page with something already there looks pleasing and helps to jump-start creative ideas.

My holiday sketchbook is also A5. I never want the daunting prospect of a large book to fill the pages of when I am relaxing on holiday. Also, portability is always an issue. I will spend a day before setting off popping prints into the book. They may be prints that are relevant to my destination, or abstract prints in gentle colours acting as a background that will often inspire an on-site drawing. I am always surprised to find that a pre-prepared page has just what I need when I open the sketchbook at a view or in a museum. There is also the added advantage of the page having something there to impress the idle observers that seem to gather when drawing out and about.

A3 and A2 sketchbooks are all about developing project work. They are certainly not portable, and I will work on these books in the studio. Materials and equipment must be scaled up when working in an A2 book and filling pages with A3 lithographic prints stops such a large book becoming completely overwhelming.

When drawing into these large pages I use the same mixed media, multi-layering techniques I would use for a much smaller sketchbook. I find the larger the page, the more scope there is for experimentation.

From A5 to A2 sketchbooks full of ideas and potential art works.

A5 sketchbooks, where I work out ideas and experiment with materials and print.

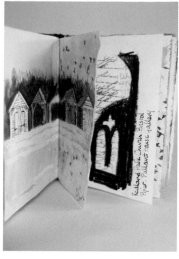

My holiday sketchbooks have pre-prepared pages to work into on site.

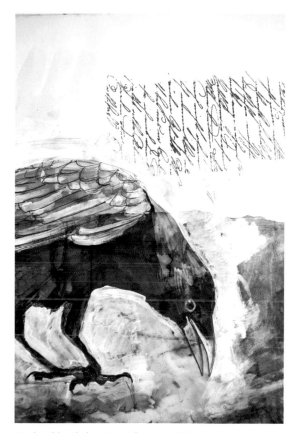

A2 sketchbook drawing with a paper lithograph background. Text can add interest to an image.

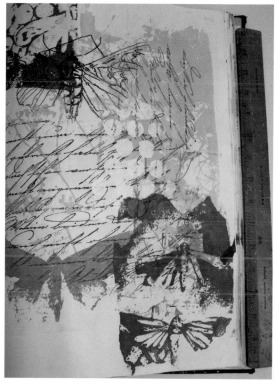

Layers of paper lithography in Prussian Blue, Cadmium Yellow Deep and Chartreuse ink.

The biggest advantage to working in sketchbooks is that everything is in one place and ideas are kept together. This does not suit everyone; there is a strong divide on the use of sketchbooks among artists, some of whom find the concept of keeping a sketchbook difficult. Other artists prefer to draw their ideas on sheets of paper and have them hung about the studio to keep that creative flow visible. I enjoy everything about a sketchbook and as a printmaker I am thrilled that I can print directly into them using paper lithography.

Of course, a sketchbook does not have to be about accomplished pencil drawing and in this chapter, I will describe the processes, materials, and equipment I use to develop a visual idea which can be made on a piece of paper or in a sketchbook. The main reason for this chapter is to describe how paper lithography can be used as part of a mixed media practice. Exploring this flexible printmaking process and combining it with other media will develop ideas or lead to a piece of stand-alone work.

DECIDING WHAT TO DO

As I outlined earlier in this chapter, I needed architectural imagery, in particular Venetian buildings, to create a body of sketchbook work. This was my first reason for using paper lithography. After checking that the book was copyright free, I scanned the images into my computer and following the process outlined in Chapter 1, 'How to Make the Right Photocopy', created a series of black and white images of Venice to use as starting points for my sketchbook pages.

The technique is ideal for adding graphic images either as a background for a composition or as the motif for a piece. In my own work I use a variety of source material. As a professional artist, I use resource material that I know the

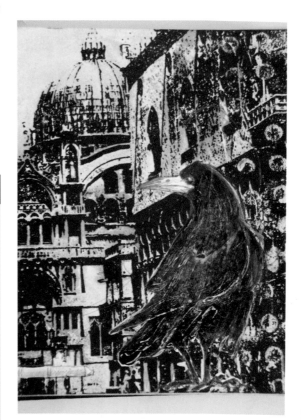

Mixed media drawn crow on a paper lithography background from the Venice sketchbooks.

origin of, either my own photographs, scans from copyright-free documents or my own drawings. I would always urge makers to use images that are taken from a primary source. It gets complicated when permission must be found to use images and not everything from the internet is copyright free. However, there are a lot of websites with available copyright-free images that artists can use. These sites offer free downloads, or it is possible to subscribe or pay for the use of a particular image. There may be technical issues with the quality of a downloaded image when trying to print it out to photocopy. Refer to Chapter 1, 'How to Make the Right Photocopy', when you have found the image you want to use.

Images from books are also subject to copyright laws, so it is important to check the age and author of the publication before scanning images and photocopying them. There are royalty-free books such as the publications produced by Dover Books, which are a valuable source of vintage and historical imagery, well worth looking at when deciding on subject matter.

These images require little work as they are already black and white, using a dot or striped texture to create tone. They will work perfectly without further editing.

Books of copyright-free images.

This image demonstrates tones made with dots and stripes of black, making it a black and white image.

Adding text, music and old maps to compositions works well. The backs of old postcards from charity shops are a great source of interesting asemic handwriting and pithy messages. Be sure to protect the identity of these sources by obscuring names and addresses. I found a lovely postcard that had chatty news from Canada to family here in the UK which contained the throwaway line, 'shame about the Titanic' hidden among trivial news. It is always worth reading the back of old postcards.

Remember to reverse the photocopy when using text, music and recognisable landmarks; it is very annoying to have an important image printed the wrong way round.

Of course, using an original drawing to print from deals with all the copyright issues that need to be considered. It is an interesting way to use original drawing in developing work.

The drawing can be scanned into the computer directly from a sketchbook piece; however, I get a better result by photographing the drawing using my digital SLR camera, particularly when the drawing is in my A2 sketchbook as this will not fit on my scanner. I can use a larger drawing in a smaller format or zoom into details abstracting the drawing to make an interesting pattern or texture in the print. A complex sketchbook drawing reproduced in this way, then turned black and white, will produce some interesting results and developments to the imagery.

As I have mentioned before, experimenting with scale is a useful creative tool. Doubling the size of a small image will produce textural line work or shrinking a large image will change its character and will tighten up the image.

Once the drawing has been printed out using an inkjet printer, it can be added to or changed before the final photocopy is done. Emphasise pale lines using a fine line marker or remove unwanted lines and marks with correcting fluid.

An extra creative step could be taken at this point by ripping or cutting up photographic and drawn inkjet prints and collaging images together. I realise that this is an analogue version of cut and pasting on the computer. It is an effective way of creating interesting random images to use as backgrounds to more complex mixed media compositions.

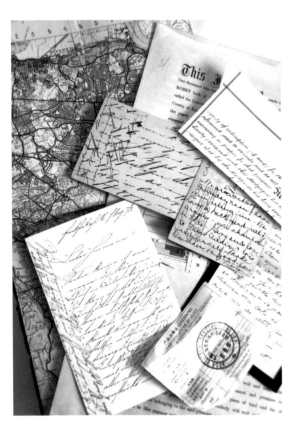

Maps, documents and postcard script.

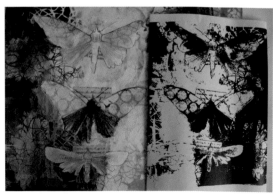

Illustrating making a photocopy from a sketchbook drawing.

Playing with scale at the photocopy stage.

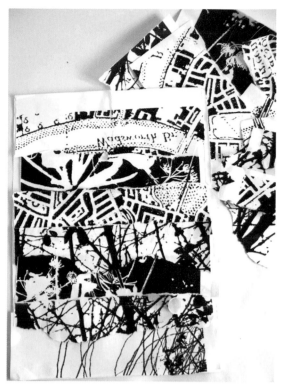

Ripping and collaging photocopies to make random imagery to print.

It is tempting to take a document, book page or drawing directly to the photocopy shop, especially if the background to the image appears white. However, a photocopier is very sensitive and may pick up background colour as a tone if it is slightly yellowed. It also may not pick up all the gentle, sensitive lines from a pencil drawing. It is always safer to put the document, book page or drawing through the 'making it black and white' on Word process as described in Chapter 1 and get the subsequent inkjet print copied.

PRINT AS A BACKGROUND

The useful thing about the process of paper lithograph is that once the decision has been made about what photocopies to print, the rest of the technique is just about getting the process right. I will often have a couple of sketchbooks or several sheets of paper out and create prints across several pages of each without thinking about what will happen next on these pages.

Decisions about colour may be influenced by the subject matter on the photocopies and also by the reason for printing onto the pages. If the printing session is about filling pages up randomly, then deciding what colours to use can be spontaneous and experimental. If the printing session is about exploring a particular idea, more thought may need to be given to the colour choices.

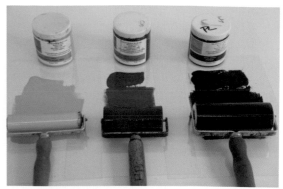
Three inks and rollers ready to start a printmaking session.

A variety of sketchbooks laid out ready to print into.

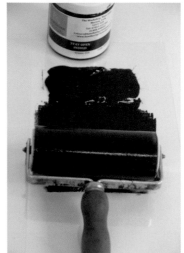
Indigo oil-based ink.

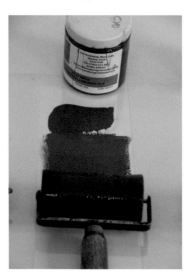
Cadmium Yellow Deep oil-based ink.

I will make a colour decision at this point and mix up two or three colours ready for printing. Having a couple of colours prepared means that I can over print copies immediately without losing momentum.

For the most satisfying random results it is best to choose a favourite colour palette. Subject matter may influence the colours to be chosen, also the atmosphere required for the finished piece. Are the photocopy images urban or natural? Abstract or figurative? Is there text that needs to have clarity? These are all things to consider when choosing colours. It is useful to think about what colours will work well together when over printing. If I am using three colours, I like to have a light, a dark and a bright hue mixed up to print with. I have several favourite combinations; colour choices are very subjective, and my favourite combinations change all

A rectangle is divided into thirds vertically and horizontally. Compositional elements placed along these dividing lines generally become more pleasing to the eye.

Grid demonstrating the golden section.

As an artist, my random placings tend to be dictated by years of considering the Rule of Thirds, therefore I am apt to place the copies down according to that rule.

I begin by printing a strip of image or text to form the structure of a composition, once the first print is down it is easier to make compositional decisions.

After printing the first copy I will take the partially inked piece and ghost print it into another sketchbook, either my holiday or small note sketchbook to start another page with a lighter print as a background. Getting two prints for the price of one inking is always satisfying.

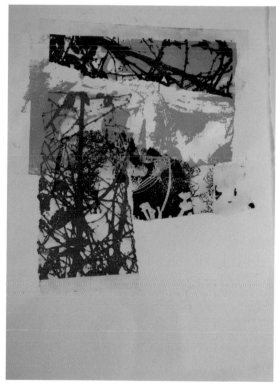

Randomly placed paper lithographic prints onto cartridge paper.

the time. Indigo with Cadmium Yellow Deep is a pleasing combination, but colour will always be a personal choice, there are no rules and interesting surprises can happen.

It cannot be helped; photocopies whether they are A4 or A3 come with straight edges. This can be a creative device or a distraction depending on what is required from the print and how the copy is handled. I very rarely print a whole A4 or A3 paper lithography print onto a page. I like to rip the copy to soften one edge, ink it up and print it onto the receiving surface randomly.

Ghost prints producing a lighter print.

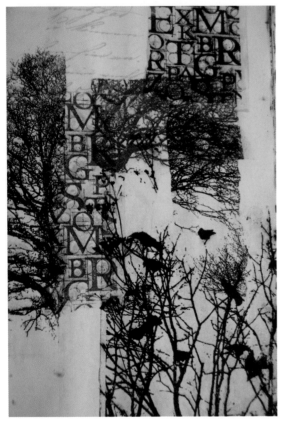
Strips of photographic imagery and text to form a paper lithography background in a sketchbook.

With the first print done I can continue to another page or build up more printed layers with other colours. The first print does not need to be dry to work another colour on top of it. Deciding how many prints to put onto a page is as personal as choosing the colour and dependent on what is coming next. There are no rules, less can be more, but rich and busy works too. Have lots of photocopies of the same image in varying sizes so that different compositions and colour ways can be explored. Some images will suit certain colours – this always surprises me. If the print has not worked out, try over printing with another colour; this may improve things.

It is to be noted that the edges of the photocopy will collect ink and print, both torn and untorn edges. When applying the gum arabic to the copy, work extra gum into the edges and the ink should spray off making for a cleaner and less distracting edge.

Do consider leaving areas of blank space for the next set of processes.

ADDING AN ACRYLIC PAINT LAYER

Once the paper lithographic layer has been established it is possible to work into the page further without having to wait for the ink to dry. This is an ideal situation for those of us keen to proceed with an idea rapidly. Have the following to hand.

- Acrylic paint
- A variety of paint brushes
- Thin card, ideally packaging such as cereal boxes
- A craft knife with a new blade
- Cutting board
- Sponges
- Commercial stencils
- Cocktail, kebab or pointy stick

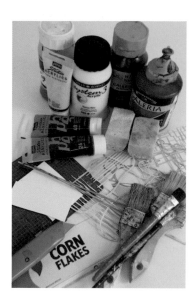

Materials required for an acrylic surface.

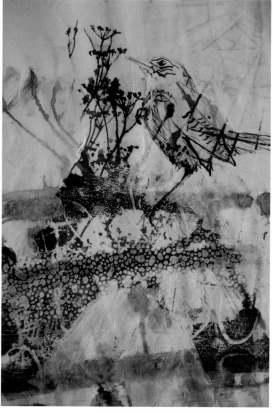

White acrylic background painted to reveal the paper lithography as a positive image.

ACRYLIC PAINT

I use acrylic paint for several purposes when developing a mixed media drawing. The instructions may look prescriptive, but I do vary the order and reasons I use the paint on the page. Acrylic paint can be used to establish more background interest or to soften the paper lithographic image using commercial stencils and masks.

The paint can be used as a surface texture to be enhanced with acrylic or Indian inks. Acrylic paint is ideal to establish a motif using stencils or painting a drawing into the composition, which can then be flooded with ink.

For these processes I use white or cream, rarely using any other coloured acrylic paint, but this is very much a personal choice. It does not matter what type of acrylic paint is used; however, the expensive paints will be more ink resistant. I often use emulsion – it is thinner and not as resistant to ink, but will be adequate for most other techniques. Match pot samples from a DIY store can be a cheap and useful source of neutral colours.

If there is a theme to a page, I will establish it early in the order of processes. I paint the image in white and create a textural finish to the painted drawing using a stick or brush marks that will be emphasised later, when I start to add ink to the surface.

Texture can be added to the background using a broad brush to apply the paint over the printed background. While the paint is still wet the paint can be scraped back using card or a pointed stick revealing the colour of the paper lithograph underneath. The texture of a paint brush mark, together with any other marks introduced to the wet paint, will be revealed during the inking process.

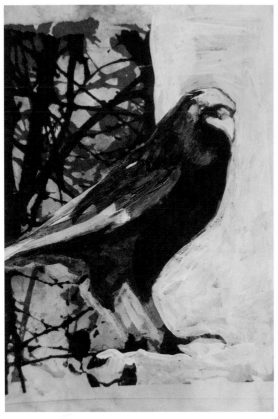

Highlights and background in white acrylic to establish an image with black ink.

Moth wings painted over the paper lithography background.

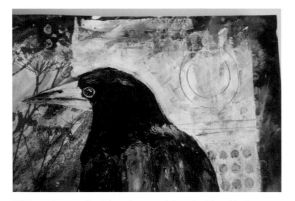

White paint emphasizing the crow's head with added texture drawn in with a stick.

STENCILS

I would always urge artists to make personal stencils to use on a sketchbook page, but this can be time consuming if a repetitive surface pattern is needed to extend the background. There are a lot of commercial stencils and masks available that offer useful textures and patterns to add to a page. It is useful to be able to soften an over-inked paper lithograph print or cover up a strongly printed photocopy edge with a pattern or texture.

Painting and scraping paint can create interesting effects. A broad brush-mark background. Paint scraped over the print to soften it and applied thinly; paint allows the print to show through.

Circle stencil worked over the lithographic image.

Step 1: Even paint out on the sponge before applying it to the stencil.

Step 2: Gently apply paint through the stencil.

Step 3: Black painted stencils can add drama to the composition.

1. Using a sponge, dip it into the acrylic paint, dab off the excess paint – this action will also push the paint into the surface of the sponge and will avoid adding a neat blob of paint to the drawing.
2. Place the stencil onto the required area and dab lightly with the sponge. Do not push down hard into the stencil as this will flood paint under the image. Build up the paint in thin layers.
3. The smaller the sponge the more accurate the paint application will be. Other colours can be used when stencilling; a strong graphic pattern can be created with black paint.

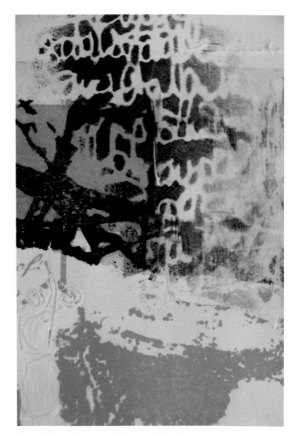

Stencilling paint can add a graphic element to work.

MAKING PERSONAL STENCILS

Handmade stencils are an interesting way to add a motif to a page; the stencilled image can be repeated throughout the sketchbook or the composition.

1. Thin card from packaging is the perfect material for cutting personal stencils. It is possible to source commercial stencil card from craft shops.

2. The plain matt side is ideal to draw onto and the shiny, printed side can be wiped clean of paint. Use a new blade in a craft knife when cutting shapes.

3. Allow plenty of space around the shape and cut the piece out carefully. Keep the positive cut-out shape to use as a mask together with the stencil.

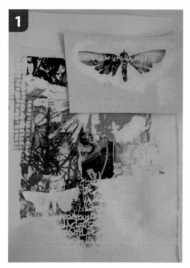

Step 1: Add handmade masks and stencils to create a motif in the composition.

Step 2: The back of packaging is matt and easier to draw on.

Step 3: Allow space around the image and keep the cut-out section to use as a mask.

4. Use a piece of sponge to stencil on the paint. Use small bouncy movements to apply an even layer of paint through the stencil and around the mask.

5. Establish the stencil motif as a positive shape or lay on the cut piece to mask out the background, covering the paper lithographic print.

I have advised the use of acrylic paint for these techniques because it will dry to a waterproof surface; this will be crucial to the processes being described next. I would always recommend experimenting with whatever is available in the studio, but it cannot be guaranteed that other paints will react in the same way as acrylic, especially water-based paints that reactivate when liquid is reapplied. Always sample on a scrap page first.

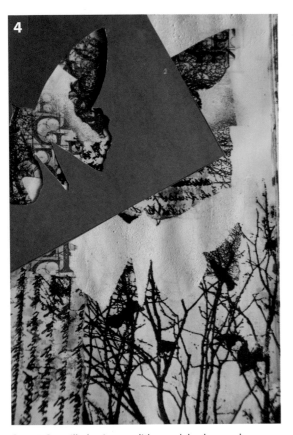

Step 4: Stencilled paint on a lithograph background.

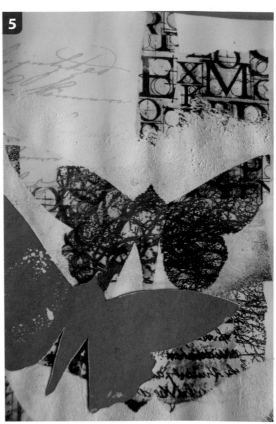

Step 5: Mask used to allow the background to be covered.

DRY PAINT

It is important that the acrylic paint dries completely between processes. To allow a page to dry, work across several sketchbooks or use a hair dryer to speed up the process. A certain amount of patience is required at this point.

ADDING WATERPROOF INK

Have the following to hand:

* Indian ink
* Acrylic ink
* Dip pen
* Pointy stick
* Brushes
* Spray bottle
* Blotting paper or kitchen towel

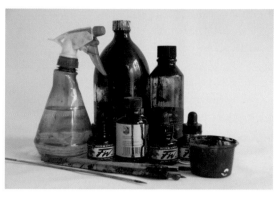

Materials and equipment for inking.

ADDING INK

With the paper lithographic print and a layer of acrylic paint painted and stencilled onto the surface of the page, it is tempting to stop, but the rule 'less is more' could be evoked at this point. The reason for using mixed media techniques is to add layers to a page and to allow details to emerge creating spontaneous mark making. Experimentation, even if it leads to an overworked, ugly piece of work, will lead to a better knowledge of how materials react to each other and what they can and cannot do. Do not be timid – it's only a piece of paper.

1. The acrylic paint and the lithograph print have resistant properties when dry; both can be washed with Indian and acrylic inks which will shed off these waterproof surfaces.
2. I like to use a good-quality dense black ink and with the addition of water, it will offer a range of tonal values.

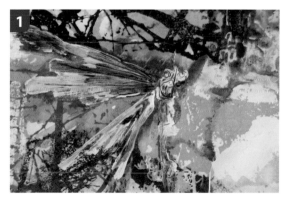

Step 1: Lithographic print and acrylic paint will resist Indian ink.

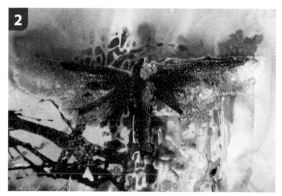

Step 2: Add water to the ink to create tonal differences to the black.

3. Indian ink contains shellac and will dry to a waterproof surface but can be manipulated with water before it dries.
4. While wet it will shed off the textural acrylic paint surface and run into any fine lines that have been drawn into the paint with a sharp point.
5. With the addition of water, the ink will run off the oil-based ink surface of the lithograph print and rest in the white paper between the prints.
6. Before it dries it can be blotted off the surface with blotting paper or kitchen towel. This is useful if the ink becomes too wet or dense in some areas.
7. I will always start gradually with Indian ink as it can be densely black without being diluted, leading to a distracting dominant mark.
8. Alternatively, using a spray bottle, spritz the area with water and draw the ink through the surface using a pen, brush, or stick.

Step 3: Wash ink with water while still wet.

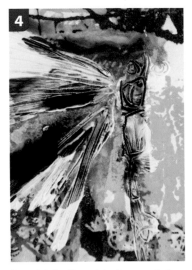

Step 4: Ink will run into lines made in the acrylic paint.

Step 5: Washed ink will rest in the white paper between lithographic prints.

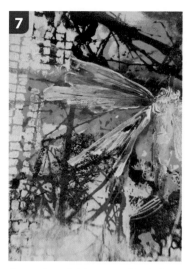

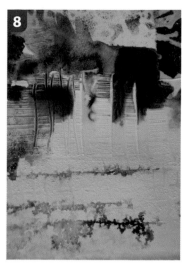

Step 6: Over-inked areas can be blotted when still wet.

Step 7: Drop ink into areas flooded with water to gradually add the ink.

Step 8: Areas spritzed with water can create interesting inky marks.

The resulting inky spread is very satisfying. The ink will also travel through the water and around the acrylic paint and lithographic prints. Add more ink where intense black is needed; the resulting contrast between white areas, gentle grey and some solid black can create dramatic compositions. Allow flooded areas to dry naturally to retain the blurred edges and interesting water marks – using a hair dryer will lead to chasing blobs around the page and making run marks that are not always aesthetically pleasing. However, speed things up by applying the hair dryer heat to the back of the drawing as it lies horizontal, this will avoid unwanted runs.

Acrylic ink will give similar results to Indian ink and is ideal for giving hits of intense colour to the piece. Acrylic inks come in translucent and opaque; always check the bottle before using them as they will give differing results over the lithographic print. Acrylic ink, if used undiluted, will sit on top of the paint surface, especially if it is applied neat with a dry brush. But it has many of the same qualities as the Indian ink and will sit within textures giving varying tonal contrasts, especially when diluted with water.

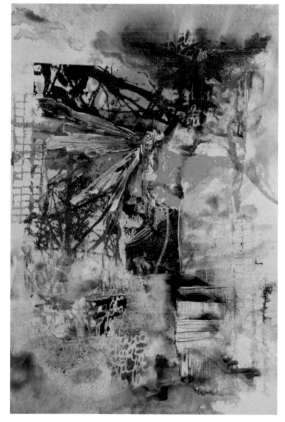

Let ink-flooded areas dry naturally to retain the diffused ink marks.

Using ink in this way will start to give the page depth, but it is easy to get carried away with the black and colours. If the ink is still wet but there is too much neat ink on the surface, prop the sketchbook up and either spray it copiously with the water bottle or run it under the tap. It is surprising the effects that can be achieved by washing a page down. However, be mindful of other pages. Allow everything to dry thoroughly before continuing to work into the area. The wash down will not disrupt the acrylic paint or the lithographic print.

If the work starts to become too dark and the ink surface is completely dry, go back into the page with the white acrylic paint using previous techniques. Pushing a stencilled pattern or drawing an image with the white paint over a dense area will save many an over-enthusiastic application of ink.

As with the paint layer, it is worth trying out whatever inks happen to be tucked away in the studio. I know that both Indian and acrylic inks will dry with a waterproof finish. But there are many water-based inks out there that will move when rewetted. Some water-based inks will absorb into an acrylic paint surface, changing colour at the same time. Other inks will change colour when bleached, which Indian and acrylic ink will not. Try things out on samples before

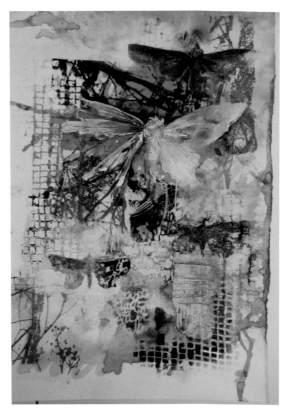

Define shapes by stencilling or painting detail.

Leave spaces or add more layered detail until the composition becomes pleasing.

committing a material to a page that is working well or use it as an opportunity for a 'what if' moment.

LEAVING SPACE

Working with different media, building up layers of print, paint and ink can lead to the complete coverage of a surface. It is useful to leave empty paper space to allow the next medium to be used to show its qualities. It is good to see how materials react with each other, but it can also be useful to see what media will do in a clean paper space. Empty negative space has its own voice and gives quiet sections in a composition. For example, the colour of a trans-lucent acrylic ink will glow in the empty spaces left between paper lithography print. Where Indian ink sheds off the acrylic paint it will sink into a paper surface and give a very different look. To stop complete coverage when working with certain materials, mask out areas using low-tack masking tape; this will lead to blank spaces of paper being left during enthusiastic ink or paint application.

To avoid tape pulling off the surface of the paper, press it onto a fabric surface first to take away some of its stick. Remove the tape as soon as the ink or paint has been applied. It will be harder to remove later. The removal of the tape will leave behind empty sections of paper sur-face to experiment with other materials.

Mask off areas to retain white blank spaces.

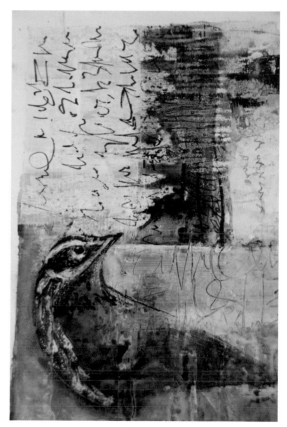

Scraping paint across the surface then drawing into it with a stick can produce interesting effects.

ADDING ANOTHER PAPER LITHOGRAPHIC PRINT

Lithographic prints are ideal for starting a mixed media sketchbook page, working well under paint and ink. However, prints can be applied to add detailing to a mixed media page when it is near completion, especially if empty spaces remain. Printing text into parts of a composition or adding a visual motif with a drawn printed image can create a focal point to the piece.

Experimentation with the technique is vital at this point as there are a few technical aspects to consider. It is possible to print onto a flat inked surface, but now is the time to carefully consider the colour used to create the best result. Metallic oil-based inks work well over the black surface of Indian ink and careful colour choices need to be made when printing paper lithography over coloured acrylic ink to allow the print to contrast with the base colour and show up.

When trying to print onto an acrylic paint surface, there are a few things to bear in mind. Paper lithography needs to have a smooth surface to print successfully, therefore textured acrylic paint will break up the image making it hard to read. As the lithographic print uses oil-based ink it will not dry quickly on a smooth acrylic paint surface. Paper lithography will print on most surfaces that will absorb the oil allowing it to dry to a waterproof finish, but it will take a long time to dry on plastic surfaces such as dry acrylic paint. For me this is a minor limitation to the process, but should be thought about when storing the work.

CONCLUSION

Whether working in a sketchbook or on a piece of loose paper this is the place to experiment with paper lithography, using it both as a starting point and as a theme motif. Paint, wash and flood it with other materials and then reverse the process and explore what materials will take a lithographic print. Once an image has been established as a sketchbook drawing, this can then be developed beyond the page using the same photocopy images into a piece of textile work, as an etching resist or in a painting.

Adding a lithographic image over the top of paint and ink.

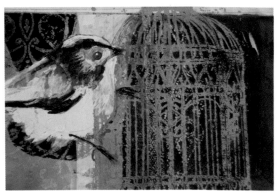

Try printing over built-up surfaces with metallic paper lithographic prints.

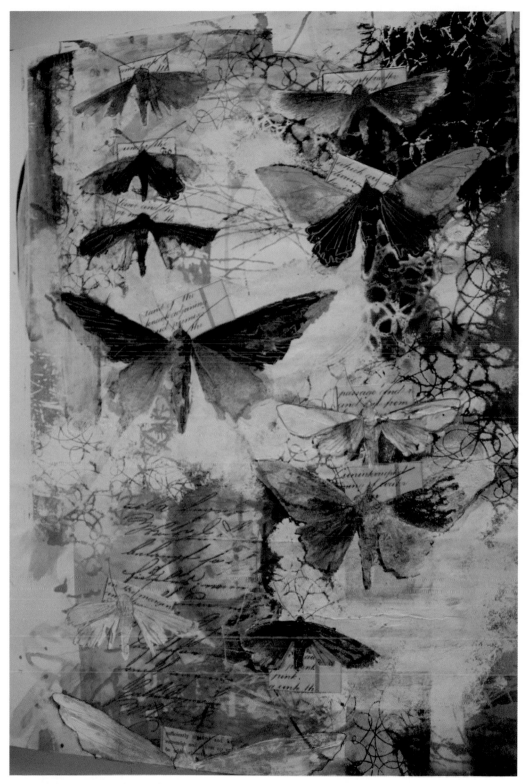

A2 sketchbook page with layers of paper lithography, acrylic paint, ink and collage.

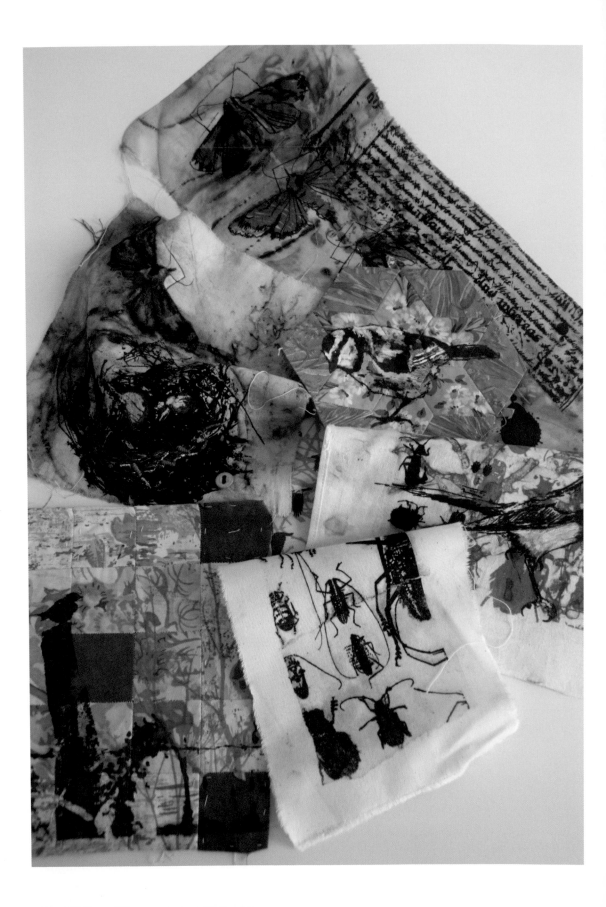

FABRIC AND PAPER LITHOGRAPHY

The term 'paper lithography' can be misleading. Of course it refers to the printmaking matrix, which is a photocopy produced on paper, but this is often misinterpreted to mean the chosen substrate to be printed onto. The printmaking demonstrations in the previous chapters have taken place on paper, but the technique with a little adaptation can be printed onto fabric as part of textile projects. The ink will transfer from the copy to a variety of textile surfaces with extra pressure.

This opens a wide range of possibilities moving out of sketchbook preparation into a variety of fabrics and textile substrates. Lithographic prints using the same inking process can be transferred onto almost every fabric surface, from smooth cottons and silks to velvets, wool blankets and pre-embroidered surfaces. The printing ink needs no setting or stabilising, and there is no need to add fabric mediums. The fabric will stay soft, retaining its handle and the printed image will wash successfully when the print has dried.

Printing onto smooth surfaces can be done easily using the pressure of a wooden spoon, as previously demonstrated. For this to be successful, a smooth shirting cotton or fine silk needs to be used. The higher the stitch count the fabric has, the better the resulting lithographic print. The print will be clear but perhaps not be as crisp as when printed onto paper using this

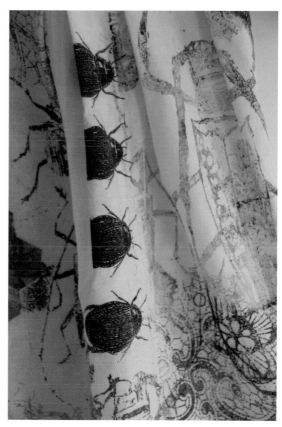

Printed and ghost printed onto thin cotton. Part of a christening gown textile project.

method, as the fine weave of a fabric surface will transfer to the inked photocopy disrupting the image slightly.

Opposite page: A selection of fabrics printed with paper lithographic prints waiting to be used for textile projects.

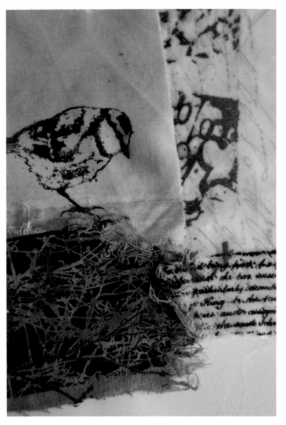

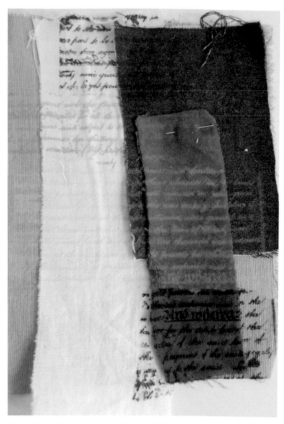

Printed examples on cotton and silk velvet together with a rough linen.

Sampling colours onto velvet, denim and cotton to find out which ink colour works.

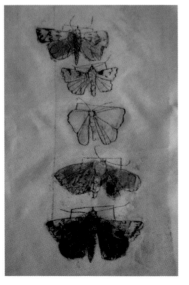

A fine lined image printed onto silk using a wooden spoon to transfer the ink.

However, to create a strong positive print on a fabric, with or without a napped surface, an etching press is required. The extra pressure of the etching press or similar equipment will press the inked copy into the surface, moulding it into the uneven texture ensuring there is no movement or blurring of the image. It enables the inked copy to be printed in one pressurised push into the surface. This works particularly well if there are sections of fabric sewn together as the wet inked copy will mould into the edges, stitches and seams, printing the image evenly with no white flashes where fabrics meet each other at slightly different heights.

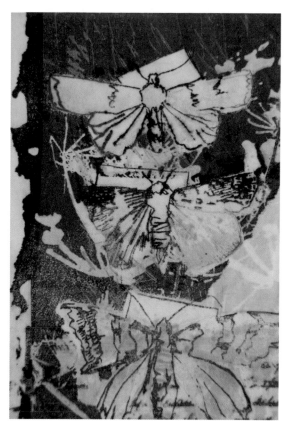

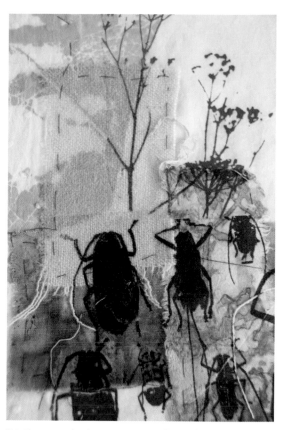

Layered photocopies printing background and detail onto a silk substrate.

Printing several colours onto a sample textile collage. Thin blanket, botanical contact printed cotton, silk and rusted fabric were used.

Paper lithographic print onto a pre-made patchwork section. Printed using a press so that there are no breaks in the ink at the seam lines.

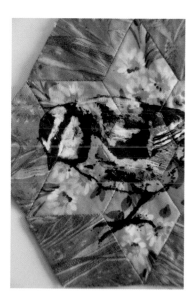

AN ETCHING PRESS

An etching press is a specialized piece of equipment. Without the extra pressure on the copy the transfer will not be strong and clear. Improvise with an old pasta maker or die cutting machine if available. However, it is surprising how many etching presses pop up when interest is piqued in certain techniques!

A tabletop etching press used in printing lithographic prints onto fabric.

From sketchbook planning to a textile project, an idea is easily transferable as the same photocopies can be used in the research and the development of the work. Moving from a sketchbook onto fabric can be made seamless. Creating new patterned fabrics, embellishing embroidered and applique work, or adding text to projects is simple and effective.

What are the advantages of using paper lithography over transferring images using screen printing? For me, it is the convenience and accessibility of using photocopies at the planning and development stage of working. Once an idea is created in the sketchbook or on paper, fabric is just another substrate to be worked on with the same images. Storing and preparing screens requires a great deal of studio space. Add to that an exposure unit to make the screen, a screen print bed and wash out facilities. Personally, getting a few photocopies together, setting up ink, gum arabic, roller and a spray bottle of water makes the process feel more spontaneous and accessible.

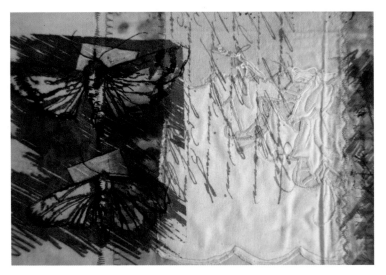

Layers of printed fine line text over a fabric collage, including embroidered vintage fabric.

PREPARING THE FABRIC

The first and most important step before diving into a stash of fabrics is choosing a theme and collecting suitable photocopied images. It is a good plan to have a variety of bold, block images and detailed, fine lined work to hand to experiment with.

Next collect a selection of fabric surfaces to sample – not only are there different textures to contend with but colour to consider. It is best to spend some time sampling different fabrics before committing to a project piece. It is important to know if the colour of the ink will show up on strongly coloured fabrics. Experiment with nets, translucent fabrics and textured surfaces, as some textiles will disrupt the photocopied image making it unreadable. Don't rule things out until the samples are printed as exciting and unexpected results can happen and preconceptions can be proved wrong.

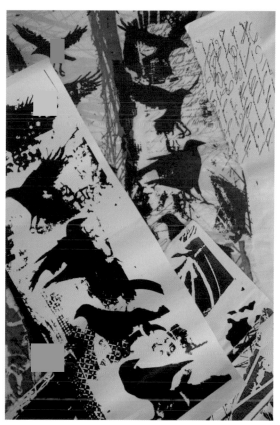

Photocopied sketchbook compositions used to print onto cotton fabric, experimenting with bold, dense images.

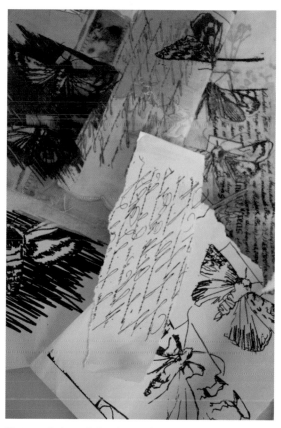

Photocopied pencil drawings and vintage documents used in the moth fabric project.

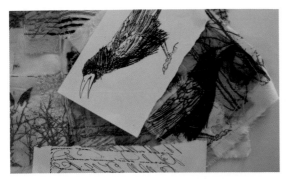

Collecting photocopies made from sketchbook work and vintage documents. Sampled first to find out how they print.

Sorting out a varied stash of fabrics for sampling.

IRONING THE FABRIC

Make sure that all fabrics are ironed flat before starting to print. It is frustrating to have a perfectly printed image that has been dissected by a crease.

Iron samples to avoid unwanted creases in the printed image.

Sampling individual pieces of fabric will create a stash of printed pieces that can be added to projects later. But this method of experimentation can be time consuming, as each photocopy will need to be inked up for every sample. It will take less printmaking time to create a fabric collage of several different textiles roughly stitched to a thin piece of calico or cotton.

This will be a mixed substrate that can be printed and over printed with one or more copies, trying out different colours and image densities over several fabrics in one go.

A rough sample using Raw Sienna, Silver and Prussian Blue ink on a variety of textile substrates, including vintage broderie anglaise.

MAKING A SAMPLE

It is useful to make a couple of fabric collages to sample, one of plain-coloured textured fabric and one with strong colour and patterned textiles. The printing ink and the image you use have much more to contend with than when just printing on plain paper.

The more sampling done, the more information will be gathered for future use.

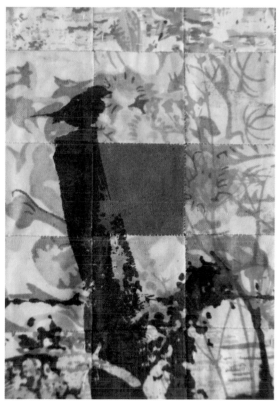

A strong block image transfers successfully onto a patterned and strongly coloured textile test piece.

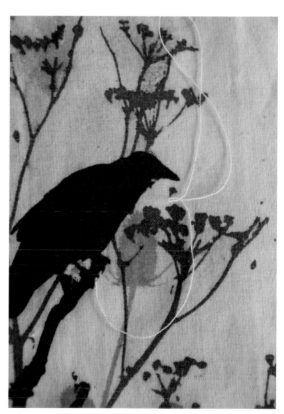

A simple white cotton background will show layered lithographic prints easily in the same way as printing on white paper.

1. To make an experimental sample, take a piece of thin calico or cotton that will fit the press bed without getting caught in the rollers at either end of the press. Don't be too ambitious with the size of the sample and check that the photocopied image will cover the different fabrics in one print.

2. Collect a selection of snippets and scraps of fabric to lay onto the base fabric. The pieces can be layered, but do not make areas too bulky as it will struggle to pass through the press evenly. Do not use anything with bulky seams, buttons or any other fastenings, as these will damage the press blankets and the roller when printing.

3. Once placed, the snippets can either be stuck down with a glue stick or pinned in place. This is a temporary stage as the glue stick will eventually dry out and the printed fabric will fall off the base. If using pins, always remove them before printing as pins will damage the press blanket.

4 To attach the pieces more securely, either tack them onto the base piece, machine stitch them, or create an intricate sample by embroidering the pieces in place. Use a combination of all three methods to experiment with how the paper lithographic print will react to the various stitching methods.

Step 1: Ensure that your copy will fit the fabric and be big enough to print onto different fabrics in one pull.

Step 2: A variety of fabrics, light and dark, textured and smooth, pressed and ready to make into a collage.

Step 3: Cut and arrange the samples across the base fabric. Temporarily attach with a glue stick. Pin sections in place and then tack onto the substrate.

Step 4: An example of firmly attaching fabric snippets onto the base fabric using a sewing machine set stitches.

Having issued a warning about the thickness of fabric layers, the whole point of this exercise is to create a comprehensive printed sample that will inform future projects, so be bold. If when printing, the sample struggles to go through the press, pare it down by taking off a layer. Never force anything that is too reluctant through a press.

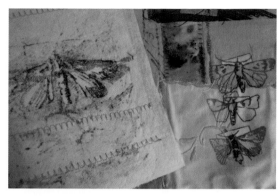

An example of firmly attaching fabric snippets onto the base fabric using sewing machine set stitches.

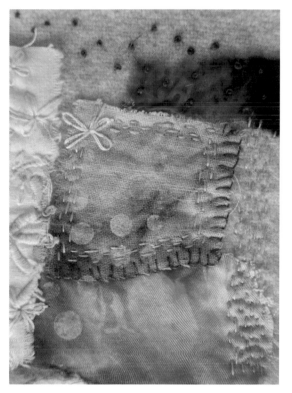

Alternatively, hand stitch and embroider samples together.

Set up the press with blotting paper to protect the blankets and have a supply of magazine papers ready to use in the printing.

Once everything is securely attached and the sample is pressed flat, prepare a working area and everything needed to print paper lithographs onto it.

To make experimenting worthwhile, create several stitched, fabric samples that can be worked through using different colours and images.

SETTING UP THE PRESS

Have everything set up and ready to use as set out in previous chapters. The biggest difference when printing onto fabric is the additional use of the etching press. Cut a piece of blotting paper to fit the press bed and place it under the press blanket. This is to mop up any moisture squeezed out of the copy during printing and will prevent the press blanket from getting too wet. Have a pile of plain newsprint or magazine paper that is slightly smaller than the press bed to hand – this is to prevent ink getting onto the blotter.

The press pressure needs to be tight to enable firm contact between the copy and the fabric, but this does not mean it should feel difficult to send the sample and copy through. Have

USING MAGAZINE PAPER

If using magazine paper instead of plain newsprint to cover inky copies when printing through the press, be warned – glossy magazines are glued together at the spine; cut this edge off as the glue can cut a press blanket at pressure. Colour supplements are better but check and remove staples.

The bottom magazine has a glued spine; the top magazine is a colour supplement, which does not have a glued edge that may cut the press blankets.

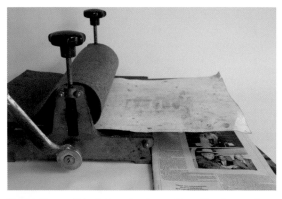

The blotter and blanket are in place with a pile of magazines ready to use.

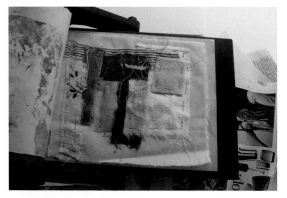

Fabric collage in place on the press bed in readiness to take the wet photocopy.

a practice with the thickest looking sample before printing with a wet copy to make sure everything is running firmly but easily through the press. Most fabrics, even those that appear quite bulky, will push down under pressure.

Lay the fabric sample on the press bed ready to take a wet, inked photocopy. This preparatory step will mean the inked copy can go straight from being sprayed clean to placement onto the fabric.

If experimenting without a press, have the fabric substrate ready to receive the inked copy. It is best to tape the fabric to a flat surface to hold it securely during the burnishing process to release the ink onto the surface. Follow the printing instructions as if printmaking on paper.

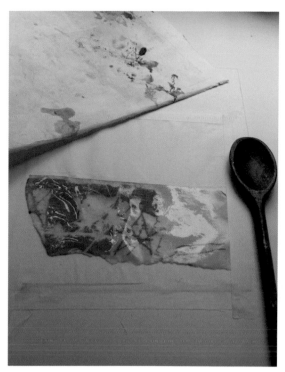

The wet copy, ink-side down on a smooth fabric taped down. This can be printed using the back of a wooden spoon with blotting paper on top.

Copy pulled back after printing.

If experimenting with alternative pressing equipment the basic set-up should be the same; the newsprint, the blotting paper to absorb excess moisture and the press pressure. It will need adaptation and experimentation until the desired result is achieved.

Several prints can be overlaid in different colours using the wooden process.

PREPARING TO PRINT

Have a clean cloth and a bottle of cooking oil ready to clean up if ink pushes through the fabric onto the press bed when printing.

With the press set up and the fabric sample waiting on the press bed, sort out a working area to prepare the photocopy for printing.

Mix a couple of inks and make a space to apply gum arabic to the copy.

Have the bucket, tray and spray bottle of water ready to clean ink off the photocopy. Follow the printmaking instructions set out in Chapter 3 until the copy is ready to print onto the selected substrate.

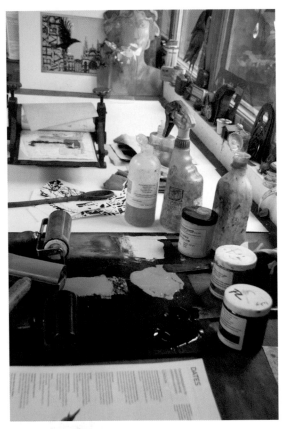

Studio layout with the press ready and three colours for printing.

PRINTING THE COPY INTO A FABRIC SURFACE

1. Carefully lay the inked photocopy ink side down onto the fabric collage in the same way as for printing onto paper. Check there are no fabric or copy wrinkles.
2. Gently cover the wet copy with the newsprint or magazine and lay the blotter that will absorb moisture from the copy. Cover everything with the press blanket.
3. Send everything through the press. When everything has reached the other side pull back the blanket, blotter and carefully remove the newsprint.
4. Gently pull back the inky copy to reveal the lithographic print on the fabric sample. Sometimes the copy will stick to the newsprint layer.
5. Take the sample off the press and using a tiny drop of cooking oil and a clean cloth, wipe off any ink that has pressed through the fabric onto the press bed.

This sample can be worked into without waiting for the ink to dry. Lay the work back on the press and continue to print onto the surfaces with different images and colours until the required result is achieved. Clean the press bed between each print to avoid unwanted ink marks.

Step 2: Cover the wet copy with a piece of magazine or newsprint, place the blotter and the blanket over everything. Adjust the presser knobs either side so that it all goes through firmly.

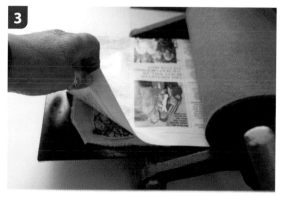

Step 1: The inked and sprayed copy laid down on the textile collage.

Step 3: Once through the press, gently peel back all the layers.

Step 4: Gently peel back the inked photocopy to reveal the print.

Step 5: Clean the press bed with a drop of cooking oil and a piece of T-shirt rag.

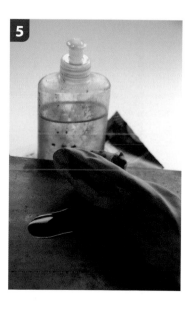

Colours can be over printed without waiting for each layer to dry.

Consider how the paper lithograph images will work on different colours and patterns of fabric.

The colours used here are indigo, bright yellow and turquoise.

WORKING INTO THE SAMPLE FURTHER

Once the fabrics and printing have been thoroughly tested, it is possible to extend the work further using mixed media techniques. Adding layers of other media onto the fabric surface is not dependent on the paper lithographic prints needing to be dry. But if further stitching is desired, either by hand or on a sewing machine, handle the samples with care as the ink will rub onto surfaces making them grubby. The image, however, is fixed and will not smear.

Looking at the printed fabric with a critical eye will mean that there are aspects of the piece that may not have gone to plan. The copy may have been over-enthusiastically inked, leaving a

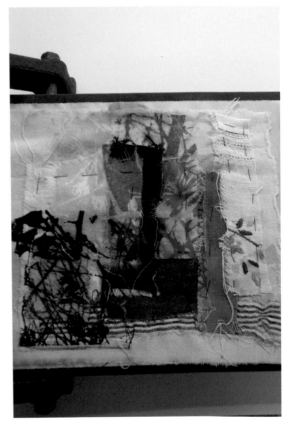

An overview of the piece shows how the colours and patterns of the print work on the different fabrics. For example, the yellow and turquoise do not really show on the denim section.

blotchy over-inked image on the fabric. Perhaps the copy printed with a strong plate tone around the image, appearing to have bled into the fabric. Or the image is too pale due to under inking the copy. Rather than abandon the sample as a failure, now is the time to experiment with other processes where over printing will not give the desired result.

STITCHING

Once the ink has dried, it is now possible to correct, enhance or change the image with stitch. An experimentally printed textile collage or a single print on a piece of fabric can be a starting point for simple hand stitches or complex machine embroidery. I want to inspire further experimentation and research, rather than demonstrating specific stitching techniques here and show examples of how a textile piece can develop when using paper lithography as a starting point.

Where ink has failed to produce a positive mark, simple stitches such as running or back stitch could be used in a matching or contrasting colour to the printed image to reinforce lines that have not printed successfully. Stitching can also soften or cover up over-inked areas and will add texture and interest to the surface. By using thread matching the background colour of the substrate, you can cover blots of solid ink – try using solid areas of French knots or satin stitch to cover any area of unwanted ink.

Different weights of thread, from fine dressmaking cottons to thicker embroidery thread or woollen yarn, will change the weight of the stitched line.

Now is the time to stitch down the collaged fabrics securely to the backing fabric as simply or with as many stitches as required. Often the original tacking can look effective and frayed edges have their own charm. An encyclopaedic knowledge of embroidery is not required; using a couple of simple stitches such as a French

A sample of different threads to embellish the printed fabric collage.

Using just a couple of stitches enriches the surface of the print. Allow the print to have space to be seen.

knot, running and chain stitch is all that is needed. Treat the activity like drawing, mark making with a needle and thread to embellish the paper lithographic print adding colour and texture to the work.

The printed and stitched example is laid on top of the photocopy. Each textile is stitched to the surface.

Running stitch, French knot and lazy daisy being worked into the printed textile collage.

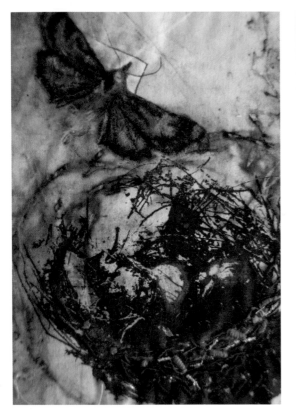

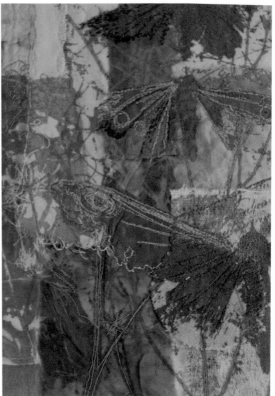

A hand-stitched paper lithographic print with applique moth embellishment, which has also had a printed image of a moth applied.

Free machine embroidery used in place of hand stitching.

Hand stitching is a soothing activity, especially when the image is established by the printmaking process and the surface has interesting qualities due to the makeup of the fabric collage it is printed on.

Machine embroidery is faster and gives a different quality to the piece .As with hand stitching, it is possible to use simple straight stitching to attach the collaged pieces – explore the decorative set straight stitches if there are any on the model of sewing machine being used. Modern electric sewing machines can be used to create complex areas of pattern and texture with free machine embroidery techniques. This takes practice and an understanding of the machine being used but is well worth exploring in combination with this graphic printmaking method.

PAINTS AND INKS

Fabric printed using paper lithography can be treated in a similar way to a mixed media paper surface. Adding stitch may be a skill too far when thinking about developing a textile piece; it does add texture, but requires expertise and patience. To develop the print adding depth and more detail, it is possible to use art materials already being used as part of a sketchbook practice.

If the textile piece does not need washing, there is no reason why acrylic paints and inks, or even water-based mediums can't be used to add layers of colour and pattern to the composition. Always try things out on a sample piece of similar fibre before committing to the work, as a fabric surface will react differently to that

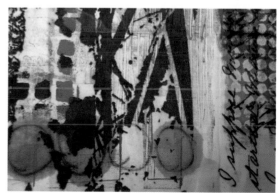

Fabric can be treated in a similar way to paper when applying mixed media. Adding layers of acrylic paint and washes of water-based inks adding colour and texture without stitching.

of a paper substrate. Some paints and inks will sit on a surface where others will unexpectedly soak into the materials or around the print. Prewashed fabric will also have a different absorbency to that of a new unwashed material. Vintage linens and cottons will often take on inks and paints rapidly, a consideration when working into a composition that includes these.

When using these mixed media techniques, the paper lithograph does not have to be completely dry to continue working into the fabric. But allow paints and inks to dry thoroughly between applications to keep lines crisp and colours bright.

ACRYLIC PAINT

Acrylic paint will sit on the surface of most fabrics when used undiluted from the tube. Using a stencil and sponge to apply the paint, it is possible to make crisp, precise patterns across the piece. It is a useful technique when trying to cover up a printed mistake or soften an over-inked image.

Applying the paint by gentle dabbing avoids too much movement or stretch in the fabric. It is possible to add fabric medium to commercial acrylic paints to retain the handle of the fabric. With or without the medium, paint will not wash out easily when dry. However, the fabric medium will slacken the paint and this may flood under a stencil.

By adding significant amounts of water to acrylic paint it will allow the pigment to soak into the surface of the fabric, spreading through the fibres and making the pigment lighter. This will not cover the lithographic print but may soak under the print, giving interesting results. Allow everything to dry thoroughly.

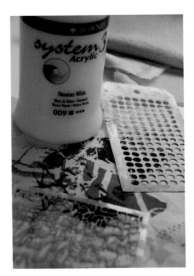

An application of acrylic paint using a stencil will break up a solid ink lithographic print.

Apply the paint through the stencil thinly using a sponge.

TRANSFER MONOTYPE

With a paper lithographic print and an area of stencilled paint, the textile piece is retaining a printed quality. It is now possible with all surfaces completely dry to add a freehand drawing that will add another graphic element to the piece. Using a transfer monotype technique and acrylic paint, this process will add a drawn element to the work.

1. Roll out a thin layer of acrylic paint onto an acetate sheet. Gently blot off extra paint with a sheet of newsprint.
2. Use a sample piece of fabric to test the paint density to avoid strong blobs of paint spoiling the work. Practise first.
3. Lay the composition image side down onto the paint surface and resist the urge to pat or rub the fabric down into the paint.

Using a dark acrylic and a roller in preparation for the transfer monotype drawing.

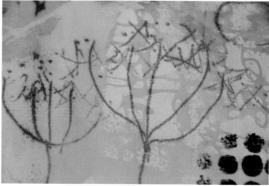

Transfer monotype is a quick and simple way to add a graphic drawn element retaining a printed feel to the piece.

Step 1: Roll out a small amount of acrylic paint onto an acetate sheet, gently removing any extra with newspaper.

Step 2: Test the paint density on a piece of spare fabric to avoid strong blobs of paint spoiling your work.

Step 3: Lay the composition image-side down onto the paint surface. Do not pat or rub the fabric down into the paint.

4. Lay a sheet of paper over the textile and draw onto the paper with a ballpoint pen or sharp pencil.
5. Hover above the work so that the drawing hand is not resting on the paint surface. Have a drawing pre-prepared on the paper.
6. Follow the existing lines until confident with the process. This added drawn monotype adds spontaneity and energy to the work.

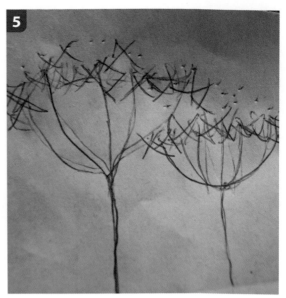

Step 5: Make sure your drawing hand is not resting on the paint surface. Have a drawing pre-prepared on the paper.

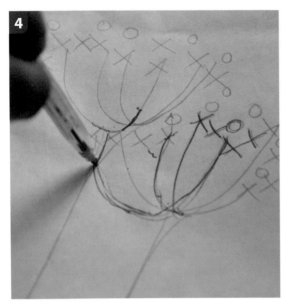

Step 4: Lay a sheet of paper over the textile and draw onto it.

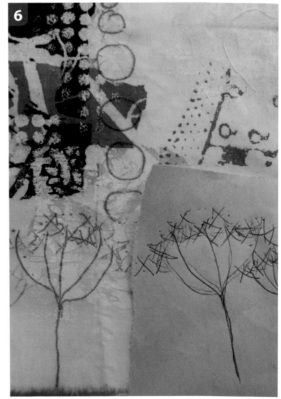

Step 6: Follow the existing lines until you are confident with the process.

INKS

Adding ink to the textile will produce soft, blurring lines and areas of strong colour. Inks have more fluidity and strength of colour than diluted acrylic paint, however it is possible to add water to most inks to give them a more subtle effect. Some inks will stain the fabric and will resist washing, for example acrylic and inks containing shellac. Others will be described as watercolour inks, always read the label and choose the appropriate medium for the project, especially if the piece may need washing later.

Ink can produce a dominant mark or colour, so sampling is essential.

Ink will also soak into a fabric due to its liquid nature; this can create unexpected results.

Adding ink to the composition can add vibrant colour to the piece, especially if a complementary colour to the lithographic print is chosen as the ink will flood around and under the image. Allow the ink to dry thoroughly between colours unless merging is required. Certainly, make sure that the ink is completely dry before adding the next layer.

Inks are ideal to add spreading coloured backgrounds around the lithographic print, stencilled paint and monotype drawing.

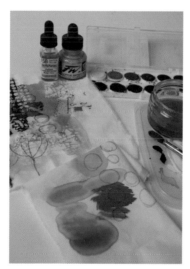

Test the inks before committing to the project, some media spread more than others especially if water is added.

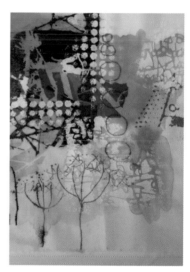

Choose colours that complement and contrast with the composition.

COVERING INKY AREAS

If the ink has taken on a life of its own as so often happens when fluid mediums are allowed to spread, go back into the piece with paint and stencils to soften a strong statement. Add extra colours and start to layer up surfaces with paint.

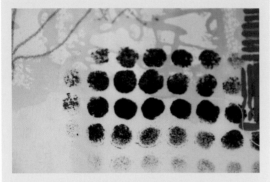

The ink can be covered by working over it with more stencilled acrylic paint in a darker colour.

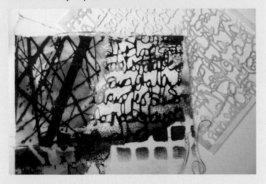

Block out solid areas using white stencilled pattern to soften it.

ADDING TEXTURE

The obvious way to add texture is by using stitched embellishments. Adding thread and appliqued fabrics changes the piece and it is sometimes preferable to continue with painted or stencilled media. Keeping a painted feel to the textile texture can be achieved by using a puff paint. This medium comes in several forms, commonly known as Xpanda print or puff paint, and is used to create interestingly textured areas to mixed media textile and paper pieces. I prefer to add my own colour with acrylic paint to the product, but it can be bought with colour added.

Add texture and interest to the fabric surface with acrylic and puff medium.

1. Put a small amount of the medium into a palette and mix with the same amount of acrylic paint. The more paint the stronger the colour, but keep the proportions to half medium to half paint.
2. Using a piece of card, gently push the mix through a stencil onto the textile. Do not press too hard as the paint will push under the stencil. Remove the stencil carefully so as not to dislodge the paint.
3. Apply direct heat to the paint using a crafting heat gun until the paint and medium expand, creating satisfying stencilled textures in areas of the composition. The colour will change only while warm.

Step 1: Put a small amount of the medium into a palette and mix with the same amount of acrylic. Keep the proportions as half medium to half paint.

Step 2: Using a piece of card, gently push the mix through a stencil onto the textile. Then carefully remove the stencil.

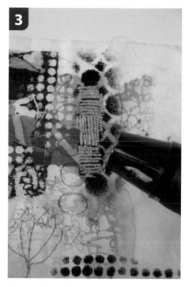

Step 3: Use a heat gun to expand the paint and medium. The colour will change only while warm.

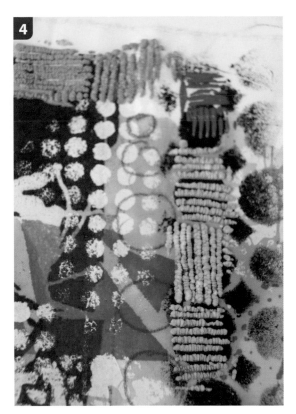

Step 4: Use as little or as much texture as you like to create interest across the fabric. I like to add small areas of coloured, stencilled surface.

4. A little goes along way, but a touch of textured colour here and there will often emphasize the printed elements. It is advisable to leave this stage to the end as it creates raised areas that do not allow stencils to lie flat on the surface and the texture becomes distorted if put through a press when printing a paper lithograph.

CONCLUSION

Once the paint, puff paint, ink and lithographic print have been completed, there is no reason why stitch cannot also be added to the piece. Working with several materials and techniques can be overwhelming. It is possible to work through this chapter using everything in order. Perhaps just choose one or two processes to work over the lithography print – there are no rules, just personal choices.

A more subtle palette of greys, pale blue and cream are used here. Text applied using paper lithography and a touch of stitch to enhance the monotype circles.

White acrylic paint has been printed over with a Prussian Blue lithographic print, knocking back the brightness of the paint. Orange ink soaks into the white fabric spaces between the print and the paint.

Hot pink paper lithography is contrasted with the orange ink. Ink floods around the white acrylic stencilled marks. Textured orange puff medium adds interest on the right.

Stencilled marks and texture with soft ink washes. Stitches add an extra dimension to this sample.

As with the sketchbook mixed media techniques, the paper lithography does not have to be the starting point – paint and ink can be laid down first and the printing process worked on top. The acrylic surface that paint gives may change the print slightly and affect the drying time of the ink, but this should not stop experimentation. The more sampling on paper and fabric, the more knowledge about how materials will behave, and this will lead to informed choices when constructing projects.

Whichever method is chosen to enhance the fabric sample, whether stitch or mixed media, allow the quality of the paper lithography to show through as an integral part of the composition. Dare to leave space in the work and let the substrate show, it is easy to overwork a piece and difficult to stick to the axiom 'less is more'. But do bear in mind that this is a sample, so perhaps this is the time to overdo it and make a richly layered, complex piece of textile.

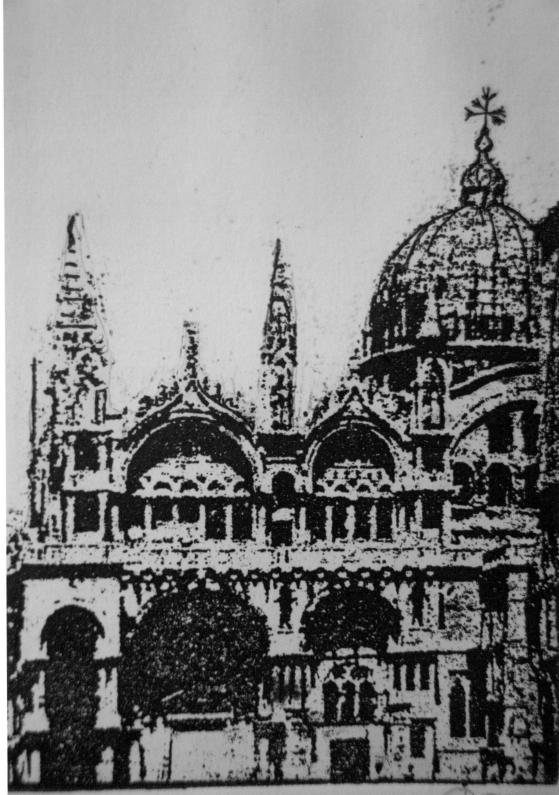

PAPER LITHOGRAPHY AS A PHOTORESIST FOR ETCHING

This book has been about making creative connections when using the printmaking technique of paper lithography. It is clear to see how it can be used to transfer drawn and photographic images as part of a mixed media practice on both paper and textile substrates and used as a tool in making and developing creative projects. However, the process can be extended and used in wider printmaking practices.

I am an intaglio printmaker and use copper, zinc and aluminium as etching surfaces. I have spent most of my printmaking career trying to degrease these metals to enable grounds and mordants to bite the metal plates to make an etched mark. Oil and grease have always been the enemy. Therefore, it occurs to me, that if oil resists the etching process of ferric chloride or copper sulphate, a paper lithographic print in oil-based ink on a metal surface will do the same, but purposely. This conclusion has led me to experiment with paper lithography prints as an image resist on aluminium and zinc. Traditional photoresist techniques used in etching are both expensive and time consuming and I find the image they offer too pristine. I like the irregular edge that the lithographic transfer gives, the serendipitous marks and how the process helps to break up the image, creating a looser, spontaneous character. It intrigues me that I can move my exploration of images from a sketchbook to a completely different process to develop an artwork.

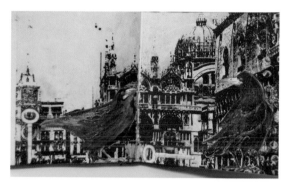

A sketchbook drawing with a paper lithographic image of St Mark's Basilica behind the hand-drawn crows. A starting point for an etching.

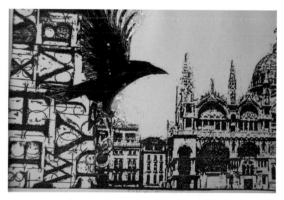

Both a text and photographic paper lithographic resist are used to create this etching. Inspired by sketchbook work, the crow is created using carborundum glued to the plate after etching.

Detail of an etching on aluminium using a photocopied image transfer of St Mark's Basilica, Venice.

Printmakers are living in interesting times; the process of etching has now become safer and there has been a lot of research into using less toxic chemicals for etching. Paper lithography as a photoresist fits in with this nontoxic printmaking ethos. Transferring the photocopied image onto a metal plate needs an etching press to make the transfer consistently even. It is an excellent way to add text to an etched print or a photographic element to a composition. I particularly like the combination of printmaking processes to create images.

There are just a few things to consider at the photocopy stage. The copy will not have to be reversed; this includes text. The image will reverse on the plate when transferred, but after processing and printing, it will appear the right way round in the print.

It might be useful to make the image into a negative before having it photocopied. I do not have image manipulating software and have found several free packages available on the internet. Consider that the ink printed onto the plate will resist the mordant, therefore the spaces will etch, and the inked surface will resist the copper sulphate etchant and print white. If the image is negative the resulting inked etching plate will be positive. This will all become clear in practice.

I use copper plate and ferric chloride in my etching practice, but this is specialised and ferric is messy. Paper lithography as a resist works very well on copper and will resist the ferric, creating clean, sharp edges and fine detail. But unless using a purpose-built printmaking studio, this may not be the easiest place to start a photoresist etching journey.

Aluminium plate and copper sulphate are cleaner, safer and more accessible to use for etching experiments. As with all etching, it is an intaglio process and will need a press to print the finished plate. Aluminium plate is very basic and as copper sulphate bites the metal dynamically, this will mean that very fine detail in images may be lost. It is best to account for that when planning which photocopies to use for this technique. However, there will always be surprises and experimentation will lead to exciting discoveries.

When this process of etching is mastered, it is not such a big leap to using zinc, copper and other safe etch mordants.

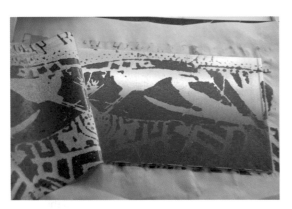

Transferred lithograph print onto an aluminium plate using an etching press. The turquoise ink sprays cleanly off the copy leaving grease-free blank spaces on the plate that will etch.

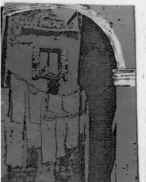

On the left is the etched aluminium plate next to the original photocopy in negative on the right. Creating a negative lithographic transfer will produce a positive etched image.

Materials required to print onto and etch aluminium plate. Be sure to label the bottle containing copper sulphate clearly.

Note that dry copper sulphate crystals can be an irritant to eyes and skin. A dust mask and gloves should be worn when working with the chemical when dry. Always read the supplier's instructions before use.

MAKING THE PLATE

Requirements:
- Aluminium plate
- Washing-up liquid
- Non-scratch scourer
- Sticky backed plastic
- Photocopy and mixed ink to print a lithographic print onto the plate
- Acrylic mat medium
- Permanent marker

1. Take the protective covering off the back of the aluminium plate. Using the non-scratch scourer and the washing-up liquid, wash the surface of the plate.
2. Degreasing the side to be printed on is essential. Dry thoroughly. Try not to handle the front of the plate directly after degreasing.
3. Choose an ink that will wash off the photocopy cleanly. I used turquoise, as it appears not to leave a plate tone on the copy.
4. Prepare the ink and photocopy as in previous chapters. When washed off, lay the copy ink side down onto the aluminium plate.

MIXING THE COPPER SULPHATE

Requirements:
- Copper sulphate crystals
- Salt
- Warm water
- Dust mask
- Rubber gloves
- Measuring jug
- Scales
- 2 litre plastic bottle
- Funnel
- Two deep plastic trays

1. Weigh out 100g of copper sulphate crystals. Using the funnel, pour this into a bottle that will take 2 litres of warm water.
2. Weigh out 100g of salt and funnel this into the bottle of copper sulphate crystals.
3. Pour 1 litre of warm water over the salt and copper sulphate. With the bottle cap firmly screwed down, mix until the sediment at the bottom of the bottle dissolves. Label the bottle clearly with the contents if using a soft drinks bottle.
4. Pour the solution into a shallow tray. The mixture is now ready to use.

PRESS PRESSURE

It is vital to have the pressure of the press correct to successfully transfer the inked copy to the plate. Too light a pressure and the copy will not transfer enough. Too much pressure and the ink on the copy will spread and distort the image. Practise setting the pressure with several test pieces until the required image transfer is achieved.

A successful transfer of a paper lithographic print onto aluminium plate.

5. Place the plate onto the etching press. The press pressure should be set to take the plate without pressing the copy too hard. Pass the plate and the copy through the press.

6. Place the inked plate onto a hot plate or into a warm oven to partly dry the ink. Drier ink will make handling the plate easier.

7. When the ink is touch dry and cool, back the plate with sticky back plastic. This will prevent the reverse of the plate etching.

Reinforce areas covered in ink by stopping out larger areas that need to remain white by using acrylic mat medium.

8. Large areas of the image that need to be white or printed detail that does not have enough ink density to prevent etching can be reinforced using acrylic mat medium. Look carefully at the surface of the ink on the plate and judge if there are pinholes in the printing ink. Paint these areas with the acrylic to avoid foul biting during the etch. Use a fine brush to achieve accurate lines and marks. Allow the acrylic to dry. Permanent markers will also resist etching and can be used to secure small white details.

9. With the transfer ink dry, it is possible to draw fine lines or sharpen lines that have blurred using a needle or etching tool to redraw into the image.

Look carefully for pinholes left in solid areas of ink as this will allow the etchant to bite through, leaving unwanted marks in white areas.

Working into the image using matt medium and permanent marker will resist the copper sulphate etching. Draw into the ink with an etching tool to make sharper lines that will etch.

ETCHING

Wearing rubber gloves, place the backed plate into the tray of copper sulphate and salt solution. The reaction of the solution on the aluminium plate will be dramatic when the solution is fresh. A small amount of hydrogen gas is released, but in a well-ventilated room this will not be a problem. Fifteen to twenty minutes of etching in the bath will give a good, deep open bite to the aluminium. It is always best to sample biting times, but it may be necessary to refresh the solution as it will weaken with use.

When the desired etch is achieved, place the plate into a tray of water to rinse off the etchant. Using the non-scratch scourer, gently rub off the ink and acrylic.

Now review the plate. If the etch has broken through areas that need white (this is called foul biting), paint a couple of coats of white metal paint over the affected areas to fill in the marks. This will enable the ink to wipe off more easily when printing the plate. It is always a good idea to ink the plate first to see how well it has been etched, but it is good to have a remedy to hand if the etch has broken through.

Lowering the plate into the copper sulphate solution (wear rubber gloves for this stage).

The solution acts dramatically with the aluminium to produce hydrogen bubbles and a reddish-brown sediment.

HOW TO DISPOSE OF COPPER SULPHATE

When etching with copper sulphate there is a build-up of reddish-brown solid. This will slow the etching process down and it is best to scoop it out. Collect it and dry for disposal as dry chemical waste, as per your local authority guidelines.

The solution will go clear when it is spent. To neutralise it add soda crystals; when the solution stops fizzing dilute with plenty of water and dispose of safely down the sink or as per your local authority guidelines.

PRINTING THE PLATE

Requirements:
- Oil-based etching ink
- 300gsm Snowdon cartridge or preferred printmaking paper
- Tray of water
- Clean piece of plastic sheet
- Blotting paper
- Small pieces of mount board
- Newspaper
- Newsprint and tissue paper
- Etching press
- Cooking oil to clean
- Rags

1. Dip the printing paper into the water tray and place on Perspex at an angle to drain.
2. Place the etching plate onto sheets of opened newspaper ready to ink.
3. Using mountboard, scrape the ink across the plate pushing it into the lines.
4. Fold newspaper over the plate and blot off excess ink; repeat several times.
5. Using squares of newsprint, polish the ink off the white areas of the plate.
6. Place the plate ink side up onto the press bed set at the previous pressure.

Step 1: Paper draining after being dipped in water.

Step 2: Plate placed in the middle of a pile of open tabloid.

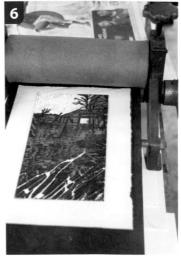

Step 3: Scrape the ink across the plate, pushing it into all the textures.

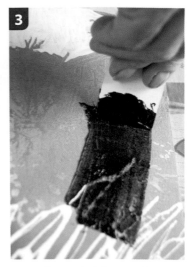

Step 4: Blot off excess ink with newspaper.

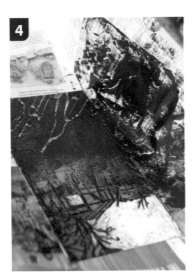

Step 5: Lightly polish off the ink working into the white areas particularly.

Step 6: Placed inked plate onto the press.

7. Clean ink off hands using cooking oil and wash off with warm, soapy water.
8. Blot the drained paper well so that it is just damp and cool to the touch.
9. Lay the paper over the etching plate, cover with the blanket and print.
10. Pull back blankets and paper to reveal the print.

Step 7: Wipe ink off hands with oil and wash with warm soapy water.

Step 8: Thoroughly blot printing paper.

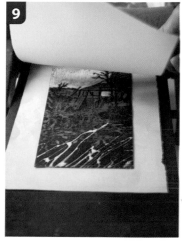

Step 9: Carefully lay printing paper over the inked plate. Pass the plate and paper through the press.

Pull back blankets and paper to reveal the print. If small things need changing, for example darkening or lightening areas, clean the ink off with cooking oil and degrease with washing-up liquid. Rework the plate with metal paint to lighten areas, or to darken areas add drawn detail by scratching dry point marks with an etching tool directly into the metal.

These etching and printing instructions are very basic. Every printmaker has their own way of making and printing work. This explanation is meant to be a start to an etching practice that can be explored further, and it takes considerable practice before complete success is achieved. Experimenting without a preconceived idea can be helpful, exploring what the process will give rather than making it conform to a specific perceived result. Every process has its limitations. Once mastered, other metals can be used and

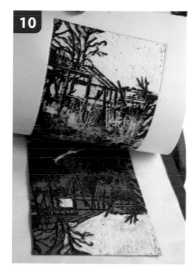

Step 10: Pass the plate and paper through the press. Carefully reveal the print.

White metal paint can be added to cover up foul biting and the ink will wipe off the plate more easily. Or add the metal paint to create interesting affects over etched areas, as in the foreground of this etching.

Here the printed etching is next to the plate, it is possible to analyse the effect of the metal paint and areas of light and dark.

other inking techniques developed. Aluminium works quickly and the chemicals used are relatively safe, but it will not give a refined finish as the biting leads to a rough-edged line. If zinc is used instead, it will work well for the finer lines of direct drawing into the dry ink and areas of detail in the lithographic transfer but will not give large areas of dark, as aluminium will. If trying both metals to compare the differences between them, use separate copper sulphate baths to etch each metal. However, the degreasing and printing of the paper lithograph image is the same, as is printing the plates.

As with every artistic process, it's perseverance and practice that leads to successful results.

ETCHING TOP TIPS

1. Before starting experimental etching, premix 4–5 litres of copper sulphate as the solution becomes quickly exhausted when large areas of aluminium are etched. Keep a bucket for exhausted solution and refresh the etching baths when needed.

2. Working on several plates at a time is a good plan. Lay down a lithographic transfer while waiting for a plate to dry, with another plate in the etching bath. This will speed up learning about the process and produces plates to compare results in etching and stop out materials.

3. Experiment with using the metal or gloss paint as a stop out during etching. This layer

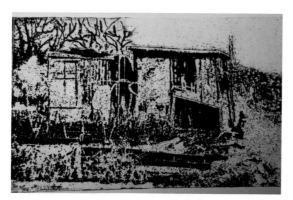
One of a series of prints using my allotment as a starting point and lithographic transfer as an etching resist.

The plate shows the use of metal paint to create white spaces in the sky and the shed. Inked in sepia.

will not be removed, as with the acrylic stop out, and will remain on the plate during inking and printing producing a different surface to the image.

4. Create white areas or limit foul bitten areas on the plate with layers of metal or gloss paint after etching. Ink will wipe off painted areas easily.

5. After etching the plate add layers of other materials to the surface; for example carborundum grit glued on with exterior wood glue to create dense black areas. Other collagraph processes can be added to the image. An excellent time to experiment with unusual plate-making materials added to the metal surface.

6. I prefer to use oil-based etching ink when printmaking, but there are Safe Wash inks that work well and clean up with water. Keep them separate from the inks used in paper lithography, as they will not work in the transfer process and cause frustration if inadvertently mixed up.

7. A specialist etching paper is perfect to print onto, but a good-quality cartridge or watercolour paper can be used as a substitute. Choose a paper that has some weight to it; nothing under 200gsm. Anything thinner and the plate corners may cut through the dampened paper when under

pressure through the press and damage the press blankets.

8. Blotting paper can be hard to source. Try using sheets of kitchen towel or old tea towels to blot the paper. These can be dried and reused. If the paper has been drained before blotting, these substitutes should be adequate.

9. Clean everything up including hands with cheap cooking oil and cotton jersey rags. Warm soapy water will get grease off everything after the initial clean. If experimental surfaces have been added to the plate, just clean the plate with oil. It is important to clean ink out of the plate after a printmaking session, so the lines do not fill up with dry ink, losing the delicate details of the image.

10. Etching plates made from aluminium will not last forever, but treated with care an edition of twenty to thirty prints should be possible.

11. When printing an edition in one go do not clean the plate between prints; allow the ink to build up in the lines. Print number five will be richer than the first print.

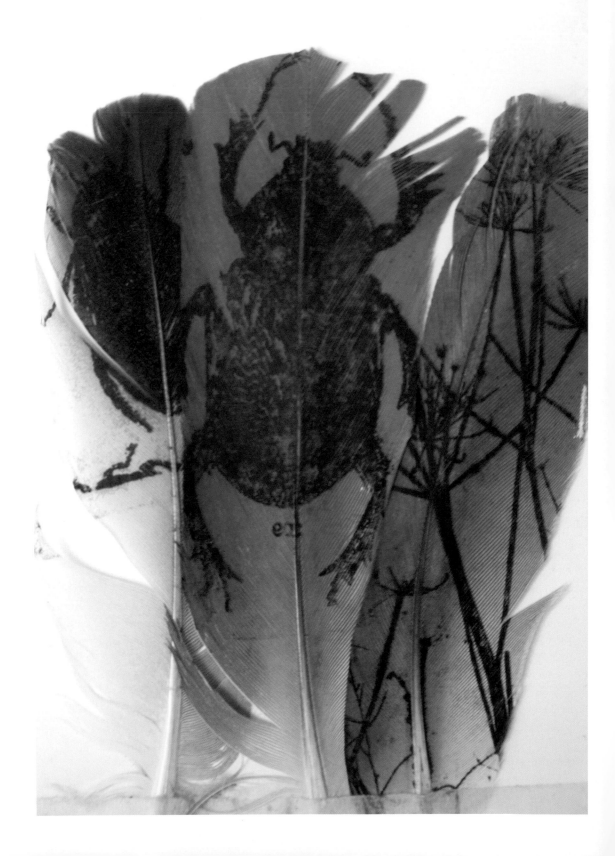

INSPIRATION

At the beginning of this book, I offered an accessible and flexible printmaking process with a grand title. I have demonstrated how to use it as a tool to explore visual ideas that can then be applied to different surfaces on paper, textiles and as an etching resist. For those excited by the alchemy of printmaking, which is basically transferring ink from one surface to another to make a mark, paper lithography has a great deal to offer. As with so many techniques, the biggest question is what to do with it? As an artist led by process it is easy for me to allow a mountain of samples to build up in the studio, beautiful snippets that can be difficult to know what to do with. The advantage of paper lithography is that it can be used at the planning stage and as part of the realisation of a finished piece.

This final section is a series of suggestions to explore ways in which paper lithography is used in project work or combined with other processes experimentally. These examples are here to inspire further personal enquiry. I hope

In this collagraph a dense area of carborundum has created a smooth area for the bird image to print evenly onto the surface. The gold ink contrasts but covers the black ink of the first print.

A smooth unprinted area of white has been left on this collagraph print to incorporate the Prussian Blue beetle lithographic transfer. Over the top of the beetle is a print of text in silver ink adding a delicate narrative.

Paper lithography printed onto a series of naturally coloured feathers.

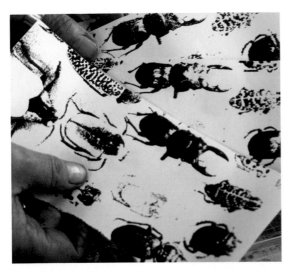

to raise more questions than answers for a creative practice and encourage curiosity. Finding a personal use for a new technique and using authentic imagery is to be encouraged. Copying examples while learning a process is initially helpful, but it is when a technique is utilised to interpret personal imagery and passions that interesting work begins to be made.

Paper lithography is an ideal technique to use to embellish and add detail to other work. In these examples the lithographic image has been added to collagraph prints. The collagraph was made with the later addition of the lithograph in mind. Collagraphs can produce textured surfaces, not ideal to add a transfer onto, but in both these pieces a smooth area was left to take the additional image. Paper lithography is an excellent way to add text or delicate imagery to enhance other prints or to add a flash of colour to a composition creating a complex extra layer. In this case using the same oil-based ink with which the collagraph is printed helps the paper lithography blend into the surface. It is vital that the print to be worked into is dry before adding the lithography transfer – this will help the lithograph to sit crisply on the surface of the collagraph. A wet print is harder to handle and will smudge during the transfer.

Over time printing a paper lithography will be thoroughly mastered; the next obvious step is to print a coloured image as a four-colour separation. This will need advanced computer skills and the ability to register the print. For this process colour separation software is needed, such as Photoshop. By using Photoshop or similar software, it is possible to split a coloured image into its four component process colours of magenta, yellow, cyan and black. The software prints out each colour in greyscale, which then must be turned into a contrasting black and white set of images as outlined in Chapter 1. It sounds counter intuitive, but once done there will be a black and white copy which will print the yellow layer and the same each for magenta, cyan and black. Use the same corner and side of

Using colour separation software, a coloured image can be split into the four process colours found in commercial printing. Each colour can be made into a black and white image that when inked up in the appropriate colour and printed together will produce this complex image.

Black and white feathers with messages from the Front during the First World War. Paper lithography being used as a safe way to reproduce precious documents.

the copy to enable the registration of each layer so that each copy can be printed over the next. Have all four colours mixed and ready to print with. Print the yellow layer first, followed by the magenta, cyan and finally the black – with the colours on top of each other, all the secondary and tertiary colours will be created. Even if there is slight misregistration the resulting image will have depth. Try using other reds, yellows and blues instead of the process colours used in printing. Use a heavyweight paper that will not cockle after receiving four wet inked copies – 300gsm Snowdon works very well.

One of the things I enjoy most about using paper lithography is its flexibility. I was asked to create a piece of work about the letters that soldiers sent home from the trenches during the First World War. I was able to make photocopies of these precious documents without damaging them and transfer the messages onto over 200 black and white feathers in silver ink. Using an etching press, it is possible to print fine lithographic images onto awkward, slightly textural surfaces such as feathers giving clear, crisp and detailed marks. These feathery prints were exhibited as an instillation at the Museum in the Park, Stroud, Gloucestershire.

Do not use feathers with pronounced fat quills, as they may damage the press blanket.

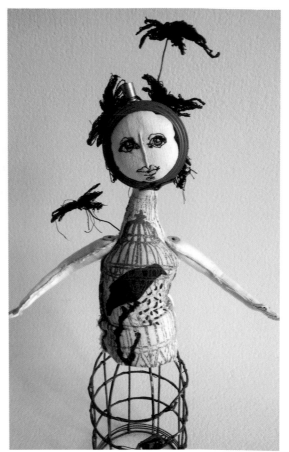

Over 200 printed feathers were suspended on nylon thread to create an installation at the Museum in the Park, Stroud.

A lithographic print is incorporated into this art doll using a variety of textile techniques. Hand and free machine embroidery embellish the double printed torso with found objects included in the figure.

Paper lithography is a two-dimensional technique, but that does not mean it has to stay flat. Using fabric as a substrate means that three-dimensional objects can be made using stitch, both hand and machine. The art doll (above right) is made with a lithographically printed textile that has been used to form the body, the image of the caged bird echoing the small cage forming the skirt. With the addition of stitching and assemblage, this brings together several disciplines.

I am fascinated by all things entomological, specifically the Victorian natural history collections held by museums. The idea that once living creatures were collected in vast numbers and stored as specimens is anachronistic to us now. Transferring my drawings of moths using lithographic techniques onto silk and then botanically contact printing the backgrounds created an artwork referring to this collecting. The silk was suspended to give the illusion of fluttering wings and constant movement. Technically it was interesting to use layers of lithographic transfer to build up the moth images and backgrounds, then boil the textile with leaves to add extra layers of image and colour to the substrate. Oil-based ink when dry withstands different temperatures without fading or smudging and the texture of the fabric retains its soft and fluttering quality.

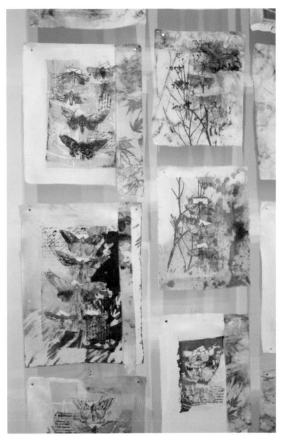

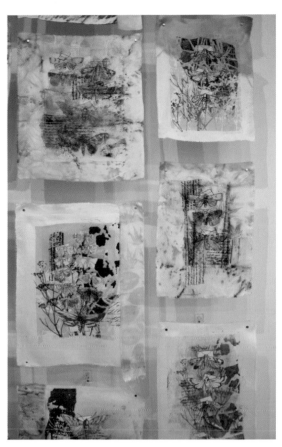

Each piece of silk is printed with several layers of paper lithographs, hand-drawn and photocopied images of moths and background detail. Some pieces were then boiled with leaves to create botanical contact printed areas and rusted sections.

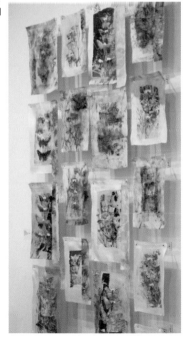

Each textile was mounted on Perspex rods to give the appearance of suspension in mid-air. The wall fluttered constantly as people walked by.

UK

Hawthorn Printmaker Supplies
The Workshop, York YO19 5UH
www.hawthornprintmaker.com
For all paper lithography and etching materials and
equipment. Ink, gum arabic, linseed, copper sulphate,
aluminium and zinc plate, rollers and presses.

Handprinted
22 Arun Business Park, Shripney Road, Bognor
Regis PO22 9SX
www.handprinted.co.uk
Specialist printmaking supplies for paper lithography.
Also other general art sundries for mixed media on
paper and textiles.

Intaglio Printmaker
9 Playhouse Court, 62 Southwark Bridge Road,
London SE1 0AT
www.intaglioprintmaker.com
Specialist printmaking supplies for paper lithography
and etching.

John Purcell Paper
15 Rumsey Road, London SW9 0TR
www.johnpurcell.net
Paper suppliers.

Great Art
41–49 Kingsland Road, London E2 8AG
www.greatart.co.uk
General art suppliers of paper, paint and inks and
some printmaking supplies.

Jacksons Art Supplies
1 Farleigh Place, London N16 7SX
www.jacksonsart.com
General art supplies including some printmaking inks
and sundries.

Seawhite of Brighton
Star Road Trading Estate, West Sussex RH13 8RY
www.seawhite.co.uk
Sketchbook and paper suppliers.

USA

Takach Press
2815 Broadway, S.E. Albuquerque NM 87102
https://shop.takachpress.com/
Printmaking supplies.

Dick Blick Art Materials
P.O. Box 1267, Galesburg IL 61402-1267
www.dickblick.com
Printmaking supplies and general art sundries.

Graphic Chemical
728 North Yale Avenue, Villa Park IL 60181
www.graphicchemical.com
Printmaking suppliers.

Utrecht Art Supplies
PO Box 1267, Galesburg IL 61402-1267
www.utrechtart.com
Printmaking supplies and general art sundries.

Acrylic ink: a coloured medium that dries to a water-resistant finish. It comes in different colours and shades, also iridescent, metallic and fluorescent. There are three different formulas of acrylic inks; translucent, opaque and semi-opaque.

Acrylic paint: a fast-drying paint made of pigment suspended in acrylic polymer emulsion.

Aluminium plate: a silvery-white, lightweight metal. It is soft and malleable and used for dry-point and etching with copper sulphate.

Applique: ornamental needlework process in which pieces of fabric are sewn or stuck on to a larger piece to form a picture or pattern.

Asemic: lines and symbols that look like writing but do not mean anything.

Baren: a tool for burnishing relief prints by hand.

Brayer: also known as a roller in the UK. A tool for transferring ink evenly from one surface to another.

Cartridge paper: paper used in drawing. Comes in various qualities and weights.

Collagraph: derived from the Greek 'colla', meaning glue and 'graph' meaning to draw. It is basically a printmaking plate made from collage materials and inked and printed as an intaglio print.

Copper plate: traditionally used for dry point and etching, using nitric acid or ferric chloride.

Copper sulphate: a blue crystalline solid used in electroplating and as a fungicide.

Copyright: the exclusive and assignable legal right, given to the originator of images for a fixed number of years.

Dry point: marks and images made directly onto a metal surface with a sharp tool. Then inked and printed as an intaglio print.

Edition: the number of prints taken from a matrix and set by the artist. Some editions are limited or can be open without a maximum number.

Etching: the process of making marks on the unprotected surface of metal plate using strong acids or corrosive mordants. This will produce an intaglio print.

Etching press: traditional printmaking equipment using a roller to push damp paper into the lines of an inked etching plate.

Ferric chloride: appears as a colourless to light-brown aqueous solution that has a faint hydrochloric acid odour. Highly corrosive to most metals and used as a nontoxic alternative to nitric acid in etching.

Ghost print: a second print made from a matrix without re-inking.

Greyscale: a range of shades of grey without apparent colour.

Gum arabic: a gum exuded by some kinds of acacia tree. Used as the binding agent in watercolour and also in the food industry.

Gum arabic transfer: also known as paper lithography. A technique used to transfer toner-photocopied images onto paper and textiles.

Hybrid prints: where several printmaking techniques are merged into a finished piece.

Indian ink: a solid black pigment. Dries to a water-resistant surface.

Intaglio: an incised image in a metal surface using a sharp tool as in dry point, or etched using an acid or mordant. The lines retain the ink and damp paper is pushed into the lines to create an image in relief.

Laser copy: as with photocopies, these are made with toner instead of ink and a heat process used to set the toner in place on the paper, creating a water-resistant image.

Linseed oil: a pale-yellow oil extracted from linseed, used especially in paint, printmaking and varnish.

Lithography: the process of printing from a flat surface, treated so as to repel the ink except where it is required for printing.

Matrix: a physical surface that can be manipulated to hold ink, which is then transferred to paper. Most, though not all, matrices are able to print the same image many times.

Mordant: a corrosive liquid used to etch metal plates.

Newsprint: unprinted newspaper made from wood pulp and an ideal rough paper for blotting and masking.

Offset: where ink is transferred from one surface to another, either accidentally or intentionally.

Oil-based printmaking ink: a highly pigmented medium using linseed oil as a binder and often thick and sticky. Solvents or the emulsification of soap is used to remove it.

Photoresist: a photosensitive resist which, when exposed to light, loses its resistance or its susceptibility to attack by an etchant or solvent.

Photoshop: an image manipulation software developed by Adobe.

Plate: a printmaking matrix such as a photocopy, etching plate or collagraph plate.

Plate tone: the light cast of ink across an area of a print that should be white.

Registration: where one image is placed on top of another, lining up the edges to create a single image using more than one plate or photocopy.

Roller: also known as a brayer in America. A tool for transferring ink evenly from one surface to another.

Substrate: any surface or material that receives a printmaking mark.

Safe Wash ink: vegetable oil-based printing inks that can be cleaned up easily and safely with soap and water. Due to this capability, they are not suitable for printing paper lithography.

Screen printing: the technique of creating a picture or pattern by forcing ink or metal on to a surface through a screen of fine material.

SLR camera: the single-lens reflex camera typically uses a mirror and prism system which permits the photographer to view through the lens.

Snowdon cartridge paper: a wood-free, acid-free paper with a white, matt surface, 300gsm, medium-textured. Ideal for sketching, as well as for watercolour painting, printing and most other applications. Particularly well suited to printing processes, including etching and water-based silkscreen.

Stencil: a thin sheet of card, plastic, or metal with a pattern or letters cut out of it, used to produce the cut design on the surface below by the application of ink or paint through the holes.

Toner: a special ink used by laser printers and copiers. It is dry and powdered in nature but is electrically charged to adhere to the paper or drum plate, which has the opposite polarity. Unlike the conventional printer ink, toner print is more durable and water resistant.

Word: a word processing packaged developed by Microsoft.

Xpanda print: a painting/print medium that creates texture when heat is applied.

Zinc plate: a metal plate that is used in lithography and intaglio printing. Zinc plates were often used as a substitute for stone, aluminium and copper plates. The metal can be etched with nitric acid and copper sulphate.

INDEX

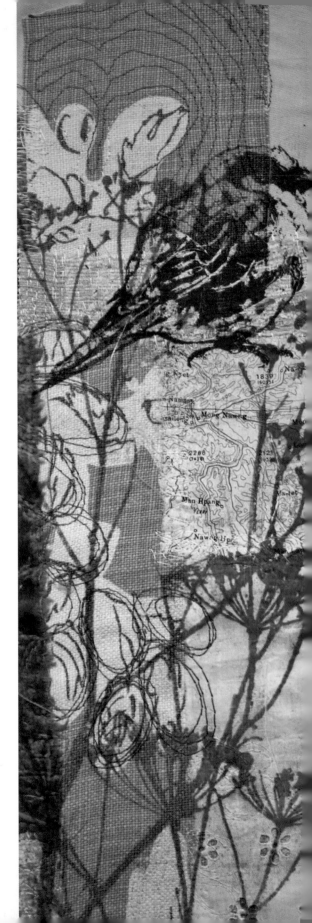

First published in 2023 by
The Crowood Press Ltd
Ramsbury, Marlborough
Wiltshire SN8 2HR

enquiries@crowood.com
www.crowood.com

British Library Cataloguing-in-Publication Data
A catalogue record for this book is available from
the British Library.

ISBN 978 0 7198 4205 4

Cover design: Sergey Tsvetkov

Graphic design and typesetting by
Peggy & Co. Design
Printed and bound in India by Parksons Graphics